PHOTOGRAPHING THE WORLD AROUND YOU

Books by Freeman Patterson

Photography for the Joy of It
Photography and the Art of Seeing
Photographing the World Around You
Namaqualand: Garden of the Gods
Portraits of Earth
The Last Wilderness: Images of the Canadian Wild
ShadowLight: A Photographer's Life
Odysseys: Meditations and Thoughts for a Life's Journey
The Garden

Books with photography by Freeman Patterson

Tribal Drums, Poems and Lyrics Selected by A.O. Hughes
In a Canadian Garden by Nicole Eaton and Hilary Weston

Books by Freeman Patterson and André Gallant

Photo Impressionism and the Subjective Image

For more information on Freeman Patterson, his books, and his
workshops in photography and visual design, please visit his web
site at www.freemanpatterson.com.

PHOTOGRAPHING
THE WORLD AROUND YOU

A Visual Design Workshop for
Film and Digital Photography

FREEMAN PATTERSON

Good wishes,
Freeman Patterson

KEY PORTER BOOKS

This book is dedicated to the thousands of photographers – from beginning amateurs to advanced professionals – who have participated in the workshops I have conducted in North America and South Africa during the past three decades. It is also dedicated to my teaching partners, Dennis Mills, Doris Mowry and André Gallant (Canada), and Colla Swart (South Africa).

National Library of Canada Cataloguing in Publication Data

Patterson, Freeman
 Photographing the World Around You: a visual design workshop for film
 and digital photography / Freeman Patterson. — 2nd ed.

ISBN 1-55263-612-7
ISBN 978-1-55263-612-1
1. Photography, Artistic. I. Title.
TR145.P37 1994 770'.1'1 C94-931076-X

The publisher gratefully acknowledges the support of the Canada Council for the Arts and the Ontario Arts Council for its publishing program. We acknowledge the support of the Government of Ontario through the Ontario Media Development Corporation's Ontario Book Initiative.

We acknowledge the financial support of the Government of Canada through the Book Publishing Industry Development Program (BPIDP) for our publishing activities.

Key Porter Books Limited
Six Adelaide Street East, Tenth Floor
Toronto, Ontario
Canada M5C 1H6

www.keyporter.com

Cover design: Peter Maher
Typesetting: Imprint Typesetting
Colour separations: Herzig Somerville Limited
Design: Keith Scott
Editing: Susan Kiil
All photographs by the author

Printed and bound in Canada

09 10 6 5 4 3

Contents

★The second edition of this book has been adapted for both film and digital photographers. Film and digital photographers will find the contents of this book equally useful.

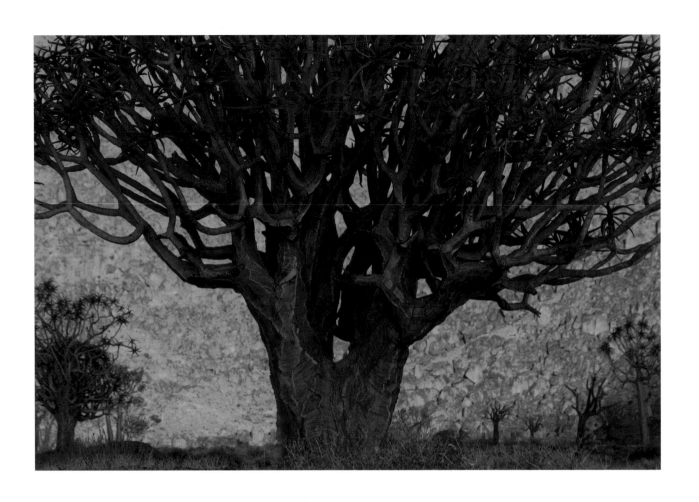

Preface

This book is a workshop between covers. It's about learning to see and about using your camera to record and interpret what you see wherever you are. It's about exploring what's around you every day of your life. For many years I've conducted several annual week-long workshops on photography and visual design in my home province of New Brunswick, Canada, and at my second home in Namaqualand, South Africa. The participants – beginning amateurs to advanced professionals – have come from many countries around the world, and over the years I have benefited as much from their visual explorations as they have from my teaching.

While I cannot recreate here the creative interaction that occurs between workshop participants and instructors, I have endeavoured to convey some of the flavour and intensity of the workshop experience. And, as much as possible, I've adopted the format and included the instructional content that my teaching partner and I provide.

I hope you will use the book to create your own personal workshop. By learning the building blocks of visual design and ways of arranging them in the picture space, by analysing and evaluating your photographs, by completing exercises and assignments that I've suggested and setting new ones for yourself, and most of all by being yourself – photographing people, scenes, and objects in ways that you've always wanted to try but never dared – you can broaden your visual horizons, strengthen your self-confidence, and make pictures that you, your friends, and many others will find deeply satisfying.

Freeman Patterson
Shampers Bluff
New Brunswick
July 2004

Learning to explore

This book about observing and photographing the world around you is a gift to you from my students – hundreds and hundreds of photographers who have attended workshops over the years, contributed their own ideas, and tackled assignments with enthusiasm, imagination, and determination. They have inspired me with their remarkable images of everyday things and given me the direct impetus for this project by encouraging me to consider an assignment-oriented book on the subject.

As much as possible, I have based the structure of the book on the week-long workshops I conduct with teaching partners in both New Brunswick, Canada, and Namaqualand, South Africa. Enrolment in these is limited to 15 or 16 participants, and in the last 30 years women and men of all ages – from 10 to 91 – and levels of expertise have taken part. The only assumption I have made here is that readers have a basic knowledge of how cameras – film or digital – and lenses work.

Most workshop days include three distinct instructional components: 1/ an illustrated lecture or two; 2/ a field trip or assignment; and 3/ evaluation of photographs made by the students on the previous day.

I begin my classroom teaching the first day with informal remarks about barriers to seeing and ways to demolish them, and with a comparison of linguistic design (the ways in which we arrange and use words) and visual design. Light is the raw material of photography, and I discuss how the two kinds of contrasts it produces – those of tone and those of colour – are the primary visual elements of any composition, actually creating the lines, shapes, textures, and perspective (the secondary visual elements) on

which all visual expression depends. On subsequent days, as in the next two chapters of this book, I consider each of these building blocks in turn and then present methods of arranging them in picture space for the clear expression of facts, ideas, and feelings. Near the end of the week I consolidate and review everything by showing students images I've made in a wide variety of situations and discussing how I applied the principles described in my lectures.

Since I can't accompany you on your field trips, in the evaluation and assignment sections of this book I offer you a selection of my own photographs made in the field, with the same kinds of suggestions I offer workshop students – key opportunities for dealing with particular subject matter, playing with design, trying different lenses, and ways of overcoming potential difficulties with technical details like lighting and exposure. My intention is to open up possibilities you might not think of on your own, to help you discard old habits of seeing.

After many years of teaching photography and visual design, I've come to realize that most participants regard photography workshops, consciously or unconsciously, as a passport, an opportunity to gain access to something far more important than the medium itself – their creative selves. Sometimes their desire to grow is so deeply buried under an accumulation of personal baggage that it's difficult to acknowledge its existence, much less to do anything about it. This is where an instructor or a friend who is sensitive to the situation can help.

I remember a morning several years ago when I was in the field with an amateur photographer who had enrolled in a workshop as a retirement gift to herself. On this particular morning, she wanted to make pictures of an especially beautiful stand of wild rhododendron. Although she obviously loved the flowers and listened as I encouraged her to try various approaches to photographing them, every composition she showed me was more or less the same as all the others – a small section of shrubbery viewed from her normal height, a definite centre of interest always placed in a "one-third position" (that is, one-third up or across the picture plane), and maximum depth of field to ensure that every last leaf and blossom was in focus. Some of her compositions were quite pleasing but, considered as a group, they all followed her rigid formula, completely masking her feelings about the subject matter. She might as well have been photographing a car, an old barn, or clouds at sunset for all the difference it made in the way she composed her pictures. After nearly an hour of trying, unsuccessfully, to loosen her up, I decided to try some shock treatment.

"Alice," I remarked, "I bet you spent your entire life teaching English – grammar, sentence structure, and things like that." She stared at me with a look of complete shock, like a child caught in the act of doing something expressly forbidden, and murmured in a voice so low I could scarcely hear her, "How did you know?"

"Because," I replied, "you love rules too much; you're afraid to experiment, to let go." And then she said something that made me infinitely sad: "It's just that I don't have any imagination."

At that point I wanted to grab both her arms and teach her how to dance. I wanted to waltz her in great, wide arcs through a field of early daisies, to swing her in circles above the shrubbery and then, exhausted, to lie on the grass as we peered up through the canopy of green leaves and pink rhododendron flowers at tiny patches of blue sky. Instead, I said, "Nobody can survive for more than a minute without using imagination. Your problem isn't a lack of imagination, but an inability to relax. You're scared stiff of trying anything new for fear that you'll make a mistake, but the whole point of your photographing these flowers is to focus on their beauty, not on your uptightness. The flowers are the subject matter, not your worries and fears." Emboldened by my own candour, I continued on in high gear. "Of course, you'll make mistakes. Great big fat ones. You'll come up with some terrible compositions, and you'll expose some good ones badly. You may even become so frustrated that you'll just want to go back to your cabin. But, if you'll accept some guidance and a few specific suggestions from me, I'm willing to hang in for another hour with you. I can guarantee that you'll make a couple of pictures that excite you and that you'll feel good about what you've accomplished."

Alice listened. Even better, she heard. "Should I choose a new camera position?" she asked. "Yes," I replied. "Instead of standing on the outside, why not move right in among the leaves and the blossoms?"

Moments later, surrounded by foliage and flowers on all sides, she called out, "I can't get everything in focus." And then she added, "Maybe I shouldn't even try, but just use shallow depth of field instead."

"Excellent idea," I called back. She was already using her imagination.

We're all like Alice – perhaps not all the time, or even most of the time, but usually too much of the time. By seeing and doing things repeatedly in the same way, we fail to appreciate the newness and freshness that we can experience in every environment, however familiar, and we risk closing down our creative selves. It may take a conscious act of will on our part, some shoving by a friend, even a shock of some sort to make us open our eyes and our minds to what's around us every day of our lives. But once we admit to ourselves that far fields are not necessarily greener, that visual exploration is possible wherever we happen to be, we can make good photographs of anything, anywhere.

Over the years I've frequently chosen a familiar object, scene, situation, or person and promised myself that I would keep exploring visually until I'd made at least twenty good compositions. (I have no upper limit.) Quite often I've selected subjects that,

initially, didn't interest me, thus making the assignments more challenging than subjects I'm naturally attracted to, and also increasing the potential for greater discovery. One such assignment was to photograph in an enclosed porch at home. It was early March; I'd been working at my desk every day for three weeks, when what I really wanted was to go outside and make some photographs. On my first free day, the weather was foul; gale-force Arctic winds accompanied by rain and hail battered the landscape, soaked my equipment, and forced me back indoors. As I pulled off my wet clothes, I looked around the porch and thought that I really must clean up this place. The accumulated jumble of old work clothes, motorcycle gear, boots of various sorts, and general debris offended my natural sense of order. However, instead of cleaning up the mess, I decided to photograph it. To make sure I wouldn't give up easily, I upped my minimum number of required exposures from twenty to fifty and set to work.

The first compositions did not come easily – as they seldom do with such assignments. I struggled to relate to the situation by examining it from many points of view and by analysing both my positive and negative feelings about what I observed. As I kept on exploring, I began to experience a rising sense of excitement that spurred me on. However, it would be dishonest to claim that I made any outstanding pictures that day. In fact, eventually I discarded all the photographs. But the exercise paid rich dividends in several ways, and I'm still benefiting from having done it.

The situation forced me to consider just what makes a jumble look like a jumble, for example, and helped me determine ways I could convey confusion and messiness visually, rather than trying to impose order on subject matter that is not orderly by nature or circumstance. Yet, at the same time, I began to perceive a small degree of organization in the chaos. Lines were repeated; shapes recurred. Spaces between similar objects were not consistently different, and tonal highlights in leather and metal objects created points of visual emphasis. By alternately scanning the entire scene and then examining specific areas, I began to see how the overall appearance of messiness, jumble, or confusion actually depends on latent patterns. This awareness has proved since to be very helpful to me in observing and photographing many natural situations – carpets of scattered autumn leaves, fields of grasses being tossed by the wind, rocks strewn at the base of a cliff, for example.

On that miserable March day when photographing in a messy porch was preferable to shooting outdoors, I had excellent opportunities to study the ways that indirect window light, falling on different materials – wood, plastic, leather, denim, metal – created a range of tones from almost white to pure black. I remember being amazed at how great the contrasts were, even though the various tonal areas had no sharp edges, as they would have had in direct sunlight. Also, I started to look carefully at the folds, the rips and tears, and the weave of the threads in old jeans and denim jackets.

I didn't allow myself to make pictures of them that day, but on several occasions since then I've given myself – and workshop participants – jeans or a denim jacket as an assignment. I've found that carefully observing and photographing these common items of clothing, familiar to everybody, have been as beneficial to my seeing as any other assignment I've tackled. In addition to these and other benefits that I received from doing the porch assignment, I refreshed my working knowledge of my cameras and lenses. After three weeks at a desk, I needed to get back in shape technically as well as visually.

Some people might have regarded my messy porch as a visual wasteland. Certainly nobody, considering it by any ordinary standards, would have termed the porch "a creative environment." Yet for me, that's precisely what it became – just as your porch or kitchen or garage or a bit of lawn can become for you, provided you're willing to explore like a child.

This means being open to "going back," as it were. It means lying in the grass and observing fluffy white clouds scudding across the sky; it means listening to music you've never heard before, perhaps because it was written long after you grew up; it means believing that a messy porch is a world waiting to be discovered. By regularly feeding your visual imagination no matter where you are, you strengthen your capacity for formulating and articulating new ideas, which in turn enables you to focus your energy creatively into worthwhile projects and directions. Those of you who are open to the world around you, who are willing to give up your preconceptions of how things "should" look, and who have wedded this openness to a good working knowledge of visual design can make extraordinary breakthroughs.

Finally, although I can teach you skills I have learned from experience, only you know why you make photographs, what you hope to accomplish through them. It may be a desire to communicate your love to friends and family or a deep interest in ecology, a wish to explore your dark side or an impulse to create images that evoke the same feelings as a favourite piece of music. The next time you are composing an image, ask yourself why you want to make that particular photograph. If you can clearly identify your motivations and passions, your reasons for making photographs, you will find that they guide your design and technical skills – and your photographs will be all the richer for that.

The building blocks of visual design

A close friend of mine who is now a very fine photographer and teacher of photography with a deep appreciation for good visual design used to expose only one roll of film a year in order "to keep costs down." Consequently, every time she made a photograph, she tried to include as many things in it as she possibly could. ("I wanted to be fair to everybody and everything," was the way she explained her all-inclusive approach.) If she wanted a picture of the village church, she'd wait for spring so she could also show a carpet of wildflowers. And she'd stand far enough away from the church so she could also include her sister's house and car, the school and its playing field, several schoolchildren, the new public toilets, a pond, a windmill, a flock of sheep, some chickens, the mountains behind the village, and, of course, lots of nice fluffy white clouds – to mention only a few of the items encompassed by her generosity. My friend saw the church as just one part of a whole community of people and things, so as long as the church was included in the picture with everything else, that was fine. However, the chances of anybody ever guessing that what she really wanted was a picture of the church were utterly nil, such was the visual smorgasbord she served up.

Not many people begin photography by building pictures the way my friend did. In fact, when you held a camera to your eye and pressed the shutter release for the first time, you probably took a picture rather than made one. What you saw through the viewfinder then and probably for hundreds of pictures afterward was what you thought was "the whole scene," not as big a scene as my friend saw, but perhaps your cat curled up asleep on a cushion, your hockey team posing in front

of a school bus, or a spectacular sunset reflected in the lake near your summer camp. This is the way virtually everybody sees; our first impression of anything is of its total configuration, the appearance of the whole.

Perhaps years later, as you leaf through an old photo album or discover long-lost snapshots buried at the bottom of a drawer, you begin to reflect on the difference between your memories of a scene or situation and the pictures you've just found. What you remembered was a very contented cat lying on a cushion, but looking at the photograph now, you suddenly recall that Uncle Harry was visiting at the time, because there's his boot sticking into the upper left corner of your snap, not to mention his fishing rod, which seems to protrude straight out of the cat's ear. And as for the sunset, how could you possibly have failed to see all those transmission wires cutting across the sky? Your memories seem more satisfying than your photographs, because in your mind's eye you focused on the main idea, theme, or content while unconsciously eliminating everything that interfered with it. Alas, the camera saw what you ignored, and your pictures prove it.

Sometimes it takes a re-examination like this to make a person realize that, although a picture is always more than the sum of its parts, the parts are extremely important to the success of the whole. Think about a big project – building a house, for example. When your house is completed, you'll want it to be functional and comfortable, as well as to look good – for your own sake, most of all. When friends visit, you hope they will also appreciate the house, but you won't be upset if they fail to notice every last brick and board, because the qualities of the entire structure (the ways everything works together) transcend the attributes of all the individual components. However, until the house is completed, you'll have to be very concerned about its design and about ways in which the design affects your choice and use of building materials.

A well-designed house or a well-designed photograph "works" properly. It does what it is supposed to do. To record scenes, objects, or events accurately in your photographs, to evoke feelings or to express ideas clearly, you have to use good design. If you think of effective visual expression as your goal – the house you want to build – then good visual design is the craft that makes it possible.

To help you understand how good visual design makes for effective visual expression, let's look first at how the good design of language makes for effective writing and speaking. As a child you learned the parts of speech, building blocks of language such as nouns, verbs, adjectives, and adverbs, and you also learned how to combine these into groups of words that other people could understand. You discovered that by arranging the same words or groups of words in differing sequences, you could subtly or drastically alter their meaning. And you also discovered that you could accomplish the same thing by varying the ways you spoke words – by altering the

pitch of your voice, by dwelling on or pausing after a particular word, by mumbling or by enunciating words clearly.

It's much the same with pictures. When you make pictorial compositions of any kind, you also use specific building blocks that you can arrange in an enormous number of ways. To create photographs, drawings, paintings, and other two-dimensional images, you employ lines, shapes, and textures. These are the most important visual building blocks, but because you photograph, draw, or paint images of a largely three-dimensional world, you must add perspective (the representation of depth or distance on a flat surface) to your short list, even though many individual images will contain little or no perspective.

As you arrange some or all of these blocks within a picture space, you communicate information. What you communicate depends both on the blocks you select and on the ways you arrange them. Whether your material is recognizable or not makes no fundamental difference to composition. Because both representational and non-representational designs are constructed with the same visual building blocks, you have to observe what these are; you must learn to *abstract*, to get behind the labels of things. For instance, an oval may be a lemon, a person's head, or just an oval, but in all cases it is the same specific shape – an oval, not a triangle or a square – with unique expressive characteristics.

Once you have recognized an object as an expressive shape, you are better prepared to use it effectively in a composition. You may choose to enhance the power of a shape (for example, that of an approaching car) by enlarging it, either by zooming in on the car or by waiting until it is nearer to your lens. This is basically the same thing as emphasizing part of a sentence by speaking one word more loudly than all the others.

Light: the raw material

The building blocks that you use as a photographer, whether they are present in your subject matter or created in your camera by the way you arrange that subject matter, are made visible by light, specifically two kinds of contrast that light produces: contrasts of brightness (also called tones or light values) and contrasts of colour (hues). Tones are degrees of brightness present within a scene or image. The range of tones may be relatively narrow or span the gamut from pure black (no reflected light) to pure white (all light being reflected). In photographic language the term "tone" never applies to colour or hue. There is no such thing, for instance, as a green or yellow tone (that is, a green or yellow degree of brightness), only light, middle, and dark tones. To say that an object is light green means it is light in tone and green in hue. By keeping this distinction clearly in mind, you will be more observant of how differences of tones and differences of colour are the raw materials from which the visual building blocks of your chosen subject matter are formed; thus you will find it easier to determine ways of altering these contrasts – by changing camera position or waiting for a change of lighting, for instance – in order to change lines, shapes, textures, and perspective for a variety of expressive compositions.

Photographers who are using black-and-white film or shooting colour images in a situation that contains either no colour or only one hue (no colour contrast being present) depend solely on the contrast of tones to distinguish lines, shapes, textures, and perspectives. Think of a green maple tree standing against a hillside background of green grass. If the leaves of the tree are lighter or darker than the grass, you will be able to perceive the tree's shape easily and record it on film. However, if the overall brightness or tone of the tree is about the same as that of the grass, you will experience difficulty. On the other hand, if the leaves of the tree are the same tone as the grass but have turned red, or if the leaves of the tree are green but the grass has turned brown, the contrast of hues will make the tree's shape stand out. Now you can use

colour effectively. Contrasts of hue in objects or scenes are very helpful in creating or making visible lines, shapes, and textures when contrasts of tone are diminished, and they are essential when tonal contrasts are lacking altogether.

When you are making colour pictures, you should always be sensitive to both kinds of contrast, however, not only because both establish the building blocks of visual design but also because colour and tones are expressive in other ways. For example, the overall colour of light recorded in a photograph can indicate the time of day the picture was made. The rich blue cast of a snowy winter landscape establishes the fact and the "feeling" of twilight; when a light (a warm hue) in the window of a house in such a scene is switched on, the colour and tonal contrast confirm the time and enhance the feeling. Similarly, the pigments present in plants and other natural things reveal the time of year and release feelings we associate with a particular season.

In addition to providing information and stimulating associations with time, colour affects our emotions directly. Consider the power of red, especially a rich, saturated red. No satisfactory theory has yet been advanced that explains why so many people "like" red, or why others prefer blue or turquoise or orange. What we do know is that colours are powerful emotional triggers. In fact, often the reason somebody photographs a particular scene or object is the dominance or even the mere presence of a certain colour or colours. Sunsets and autumn leaves are two of many obvious examples.

Tones have a similar capacity to generate emotional responses. Surrounded by very bright tones with few contrasting dark ones, we often experience a sensation of lightness, of liberation and freedom. We "feel good." Conversely, many people who live at latitudes where winters are long and days are short suffer from seasonal affective disorder, a syndrome characterized by a diminished sense of physical and emotional well-being, lethargy, and a strong desire to escape the darkness. If those of us who are affected by the disorder could hibernate, which our bodies are pleading with us to do, we would not need to spend so much time and money seeking longer days, which is to say, more and brighter light. In short, tones, like colours, trigger a wide range of emotions.

Sometimes your personal feelings or ideas are the real subject of your images, and the objects (subject matter) in front of your lens are visual metaphors for them. In these cases the material you choose to photograph (the sun, a studded leather jacket), its colours and tones (a golden hue, strongly contrasting light and dark tones), and its component building blocks and designs (a series of radiating straight lines, a large bold circle) may all have symbolic value. The challenge in employing symbols effec-tively is to achieve harmony between the symbolic content and the symbolic style. For example, a person who makes an apology in an angry tone of voice is using

disharmonious symbols. The words (content) and the tone of voice (style) just don't go together. Change the tone of voice to a more pleasing one and the message will be more effectively delivered. Similarly, the sense of hope often symbolized or evoked by the rising sun will be enhanced by overexposing the scene slightly to produce light, delicate tones.

While the brightness and colour of light establish contrasts that create lines, shapes, textures, and perspectives, arouse emotions and have symbolic value, both the quality of light (its harshness or softness) and the direction of light (frontlighting, sidelighting, and backlighting) have the same potential influences. In particular, the quality and direction of light can enhance or diminish the clarity and definition of naturally occurring lines, shapes, and textures. Since the end result is to alter the appearance of what is being documented or expressed in a photograph, let's take another look at light and lighting.

When light is indirect or diffused – for example, on an overcast day or when light from a flash unit is bounced off another surface onto your subject matter – it has a softening effect. This is because the number of tones tends to be reduced, the range of brightness tends to be compressed, and the transition from one area of tone to another is often quite gradual. When light emanates from a point-like source, such as the sun or a flash aimed directly at your subject matter, the number of tones tends to be increased, the brightness range tends to be extended, and, in particular, transitions between different tonal areas are abrupt or missing altogether, resulting in crisp, sharply defined edges. This is especially so when direct light shines on your subject matter from above, below, or either side (sidelighting) or from behind (backlighting). However, when direct light shines on the parts of your subject matter facing the camera (front-lighting), it may produce effects that resemble those of diffused lighting; limited tonal range is not uncommon, and the absence of visible shadows that function as dark lines and shapes tends to produce a flat, two-dimensional appearance. You can usually overcome this flatness by adding even a little sidelighting, or by moving your camera position slightly to one side or the other, while aiming the lens back at the area of your original composition.

Take another situation, one familiar to every photographer. Direct sidelighting that produces strong shadows emphasizes lines and wrinkles in a face and can make a middle-aged person look like a very senior citizen. Soft (indirect) lighting that produces gradual tonal changes will convey a more accurate impression of the person's age. Yet the same direct lighting that emphasizes wrinkles will outline the contour of a person's head when viewed from the proper angle (backlighting), and what was termed "harsh lighting" can be described as "dramatic lighting" instead.

Although harsh and soft lighting, of themselves, do not alter a hue or its saturation,

The compositions of these two photographs of similar scenes both depend on strong tonal contrasts that make lines and shapes stand out clearly. The dark tones, in particular, form lines that lead our eyes to all parts of the pictures. In the autumn scene opposite, however, the vibrant red colour creates a shape that is missing in the winter scene, where colour is almost absent.

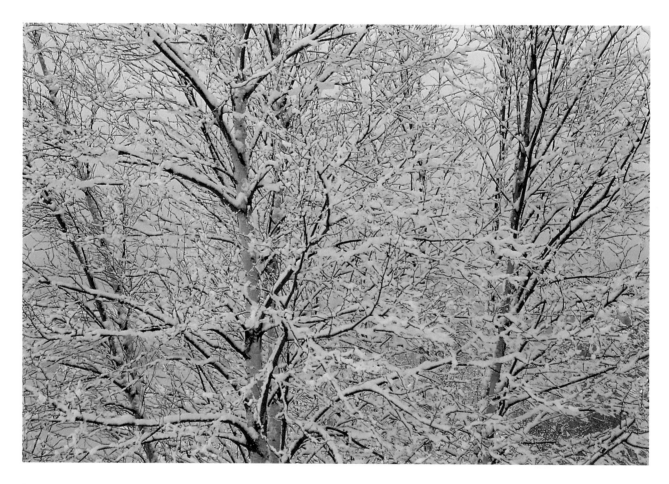

Colour contrasts, like contrasts of tone, form lines, shapes, textures, and perspectives that photographers use to create expressive designs, but the various hues and their saturation or richness also affect our moods and our perceptions of time or season. Although I depended on tones more than colours in organizing both these images, the rich warm colours of the autumn scene and the virtual absence of colour in the winter scene not only indicated the season but also motivated me to stop and make pictures.

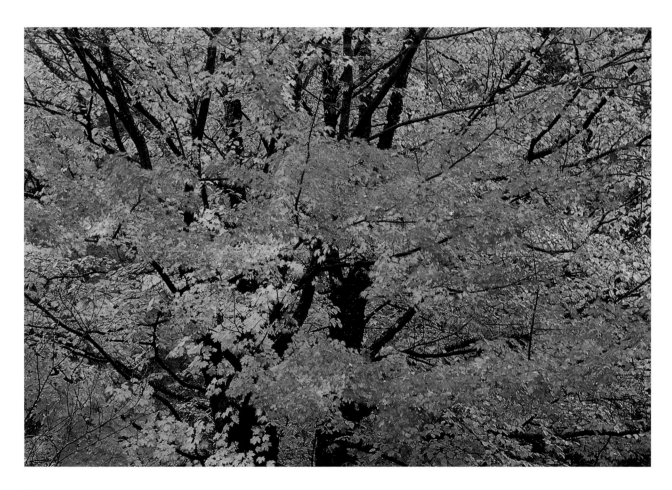

they may appear to do so. Usually, this change in the appearance of a colour is the result of tonal changes. In brilliant direct sunlight the golden hue of a rose blossom may seem to be enhanced by tonal "highlights" and by the black shadows between and behind the petals; in diffused light the dark tones of shaded areas and any highlights in the blossom will be absent or less intense. This compression of the range of tones means that the hue of the blossom has a relatively greater influence on the flower's appearance. The result may be less dramatic, but the rose will seem to glow with an inner warmth. Unfortunately, because most people have been conditioned to believe that colours are more brilliant on a sunny day than on a cloudy one, they often literally do not see what is in front of their eyes. For example, autumn colours are never more intense than on an overcast day after some rain has fallen (see page 21). By comparison the same scene will be quite washed out in bright sunlight unless viewed at particular angles of sidelight or backlight early or late in the day.

Both soft and harsh light may evoke emotional responses, but remember that when it comes to visual design, the direction of undiffused or harsh lighting is significant primarily because of its clear effect in creating and defining visual building blocks. It's the resulting lines, shapes, textures, and perspectives that you have to arrange in picture space − not frontlighting, sidelighting, or backlighting. Visually and mentally, always stay focused on these basic elements. It is these, appropriately arranged, that will enable you to document the world around you and to express your feelings and ideas in an endless variety of ways. So let's consider each of them in turn.

Line

A line leads the eye – and the mind – across a picture space. It is the most fundamental building block of two-dimensional visual design, and is always made visible by the juxtaposition of three areas of contrast – the tone and/or colour of the line itself and the tone and/or colours on either side of it. In drawing, a line begins as a dot that is extended across space, cutting it into two shapes. The line creates the shapes, as it were. (To take a less conventional view, one may think of a dot as being a line viewed from either end, the line itself and the shapes it creates becoming visible only when the viewer moves up or down or sideways.)

Every line has several expressive qualities or characteristics – length, character (straight, curving), orientation (vertical, horizontal, oblique), thickness (fixed or varying), and relation to other lines (spacing, repetition). Let's consider these in order.

Length: The longer a line is, the greater its visual importance, effect, or impact is likely to be.

Character: There are really only two kinds (or characters) of lines – straight ones and curved ones, but curving lines may have a single curve or many, and these curves may vary in size and degree or be identical. Curving lines that frequently vacillate or fluctuate in direction are often referred to as "wavering" lines.

Straight lines are unambiguous. Because they move without deviation from one point to another, they impart a sense of purpose. Curved or curving lines, on the other hand, always imply digression. They suggest unhurried travel, physically and mentally, and usually have the effect of slowing down or relaxing the viewer. Both kinds of lines are present in the composition of water grasses on page 24, but because curving lines predominate, and most of them terminate within the picture space, there is an air of restraint or quietness about the image.

Orientation: The orientation or position of straight lines has enormous expressive power. There are three possible orientations – vertical, horizontal, and oblique.

This quiet scene contains only one colour (a highly saturated fuchsia) and two tones (the dark of the grasses, the middle tone of the water). The colour indicates the time of day and establishes a mood. The contrast between the two tones makes the lines clearly visible. In determining the composition, I was careful to avoid camera positions that had the effect of grouping or clumping lines together, which would have reduced the delicacy of their arrangement.

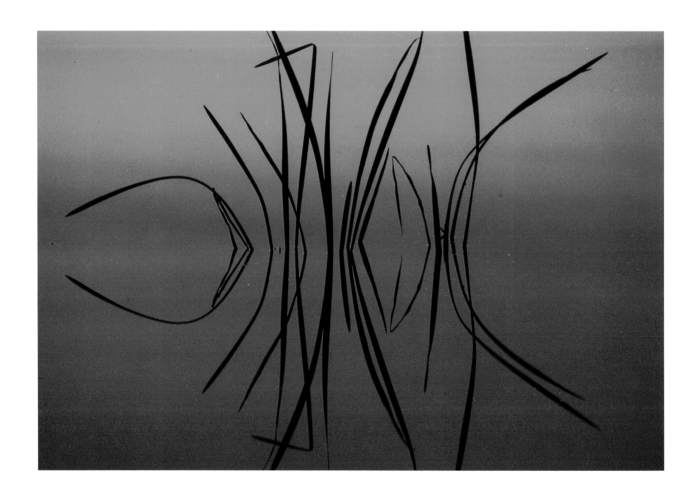

Because straight lines appear to be stable (at rest) in both the vertical and horizontal positions, they impart a sense of stability to a composition. Vertical lines may also convey stiffness and formality, especially if the spacing between successive vertical lines is fairly equal. For instance, think of a row of diplomats posing for a picture at a conference. The effect is usually one of strong order and precise arrangement, as with a row of columns on a classical building. Also, depending on the subject matter, the equal spacing of very straight vertical lines can evoke the feeling of military precision. However, vertical lines may also suggest strength, power, and even growth (a direct interpretation from our experience of seeing so many trees and other plants standing in a more or less vertical position). Horizontal lines appear to be even more stable than vertical ones, echoing the solidity of a floor or flat land. If horizontal lines are not absolutely straight, but undulate slightly, they may evoke a feeling of restfulness. Our response to such lines is often the result of experience – usually we make our bodies horizontal and slightly curved when we want to sleep.

The photograph on page 26 contains several parallel lines and several parallel shapes, both in the vertical and horizontal positions. I decided on this formal arrangement of lines and shapes as a contrast to the naturally random arrangement of stalks, leaves, and blossoms on the climbing rose. If I had made the setting less formal and more dynamic, perhaps by shooting when sunlight and shadows spilled across the fence, I would have drawn attention away from the roses.

Lines in an oblique position generate dynamic, a sense of life, movement, and change. This is because, subconsciously, we regard oblique lines as having been knocked out of the vertical position and moving towards the other position of rest, the horizontal (or vice versa). We see and we feel the instability. If you are endeavouring to improve a composition that seems to lack the vitality or movement that the subject matter or your feelings call for, you can often gain the effect you desire by reorienting or moving your camera in a way that alters the orientation of an important line or lines from the horizontal or vertical position to an oblique one. This is what I did when I was photographing the morning mist, shown on page 27. From my original position on a bridge, the shadows of the trees streaming across the mist below me were vertical lines. In order to eliminate the formality they conveyed and to achieve a sense of movement, I moved a few steps to the right and then aimed my lens back at the scene. The shadow lines were now oblique, producing the effect and evoking the feeling that I wanted.

An oblique line that traverses the picture space from one corner to the opposite corner (upper left to lower right or lower left to upper right) is called a "diagonal," and bisects the image into two equal triangles. A diagonal line, unlike other oblique or slanting

The vertical and horizontal lines of the fence and the house provide a formal visual structure that, by contrast, emphasizes the curving, sprawling lines and red blossoms of the climbing rose. Although I made several different compositions at this spot, I prefer those in which the roses themselves occupy relatively little of the picture area but have a clear visual habitat or sense of place.

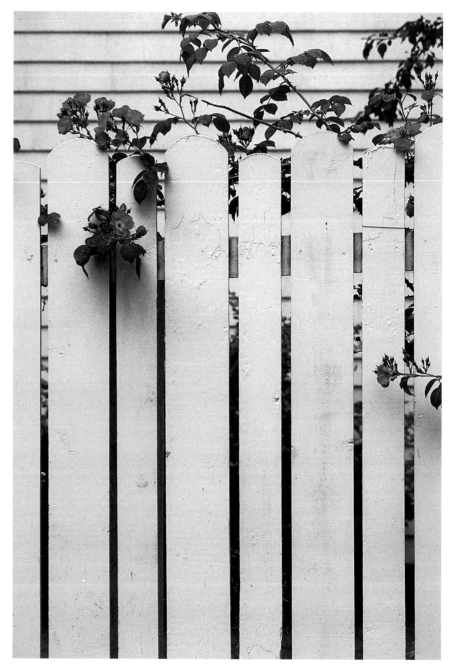

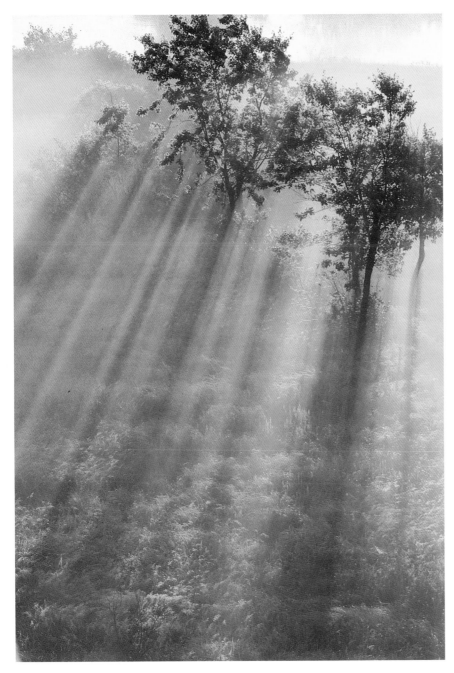

To capture the evocative lightness of morning mists, a photographer will have to increase the camera meter's recommended exposure by opening the lens one to one-and-one-half f/stops or by decreasing the shutter speed by an equal amount, especially when the mist fills the entire picture space. When mists are backlighted, the shadows of trees or other objects may form dramatic rhythmic lines. You can increase their dynamic effect by choosing a camera position that gives them an oblique orientation.

lines, always induces a strong sense of balance. (Almost no other term in visual design is used as carelessly as "diagonal," which has the precise meaning just indicated.)

Thickness: The thickness (or breadth) of a line or lines will influence the feeling or mood of many images, and should therefore be carefully considered. For instance, if I had moved closer to ("thickened") the grasses in the photograph on page 24, I would have reduced the sense of delicacy the lines induce and created a more starkly graphic, non-representational composition. On the other hand, the thickness of the three major oblique lines on page 125 (the line of the biker's leg and the two lines of metal in his motorcycle) suggest strength and power.

Lines that diminish in thickness as they cross the picture space create the illusion of depth or distance (perspective), just as they would in the actual situation. You can augment or diminish this impression by the lens and camera position you choose. (See *Perspective*.)

Relationships between lines: I'll be examining a number of relationships between lines and/or edges in several ways throughout this book, because they all influence expression. To prepare for these discussions, note the use of repeated lines and edges in images on pages 29, 48, 74, 103, 119, 133, and 155. Also, note the integration or weave of lines (texture) in the images on the lower half of pages 140 and 141.

A line that is differentiated by strong contrasts of tone or colour from the spaces on either side of it will have much greater expressive force than one differentiated by weaker contrasts. Sometimes, a photographer can vary the contrast ratios – in either direction – to modulate the effect.

Not all lines in a photograph, drawing, or painting are visible, and the ones you can't see may be as important as the ones you can. Imagine a small area of dark grey sand with two white stones lying on it. Your eyes will tend to move naturally back and forth between the two spots of lightest tone. This movement will increase once you frame the scene in the viewfinder, because you will have eliminated any visual competition from nearby objects on the beach. The movement – or implied line – between the two stones will be vertical, horizontal, or oblique depending on where you place the stones in the viewfinder, and it will be as expressive as an actual line in many instances. If there are several distinct dots on an otherwise clear field, your eye will automatically and subconsciously endeavour to link them in the simplest way possible. This produces the mental imprint of a line on the image, a line that has a beginning point, several points where it may shift direction, and a final resting point. If the line curves back on itself or seems to enclose space, your mental imprint will be of a shape, and you will impose that shape on the visual field. For example, the placement of the various people in the bottom photograph on page 163 forms a rough circle.

Edges resemble lines; they have most of the same properties (length and orientation, for example) and produce similar expressive effects, but generally these effects are

This picture of a row of beached canoes was made early in the morning just before sunrise. Had I shot it when the sun was up, the contrast of strong light and shadow would have created sharp lines along the keels of the boats, but in this gentle, diffused light, there are no actual lines, only "edges" where one body of colour meets another. The effect is softer and more abstract, emphasizing colour and shape rather than linear divisions.

somewhat less pronounced. The difference can usually be attributed to the fact that although every line has some width (and this width, however limited, is visible), an edge has no width at all. In fact, we don't actually see edges, because there is nothing to see; we "intuit" them instead. Take the horizon, for example. There is no horizon line in most cases, even though we often speak of one. Almost always it is an edge, the place where the shape of the sky meets the shape of the land. You can also see this effect on page 29.

If a line completely or nearly encloses a shape, we call it an outline. A painter who wants to define a shape more clearly can easily convert one or more of its edges to a line; all he or she has to do is outline the shape with paint of lighter or darker tone or of another colour. A photographer usually finds the task more difficult, but in many instances can add supplementary sidelighting or backlighting, which rims the shape with a lighter tone (a person's head in a close-up, for example). This usually works well with objects fairly near to the camera, but it is seldom of much help with distant objects. To define their shapes more strongly, you must wait for naturally occurring sidelighting or backlighting, or perhaps frost, to transform edges into lines, or seek alternative solutions, such as moving closer to objects in order to enlarge their shapes within the picture space.

Lines and their orientation create shapes, especially in conjunction with the edges of the picture space. A diagonal line bisects a picture into two equal triangles; a vertical line that runs from any point on the upper edge of the picture to the identical point on the lower edge forms two rectangles. The shapes that result from the placement of these lines may be more visually significant than the lines themselves and require the photographer to rethink the composition.

One morning, for instance, when I stepped out onto my porch to get an armload of firewood, I noticed that the sun's strong sidelighting was catching the curving peak of my black stetson, which I'd tossed on a hook. I dashed back inside for my camera (always loaded with film and attached to a tripod) and returned immediately to the porch. The curved line of light did not complete a shape, but almost produced one, which I recorded with a 100mm macro lens from a distance of about one metre, with the camera tilted to give a slightly oblique orientation. (See page 31.)

The skilful use of lines makes for clear and effective expression. The fewer the lines in a composition, the simpler it tends to be, since the viewer's attention is not drawn in conflicting directions. However, a multitude of lines can form a good composition when they work together to give a sense of unity. For instance, the image on page 155 is an even more dramatic example of how numerous lines (especially strongly contrasting ones, harmoniously arranged) can radically affect both the appearance of a scene and our emotional response.

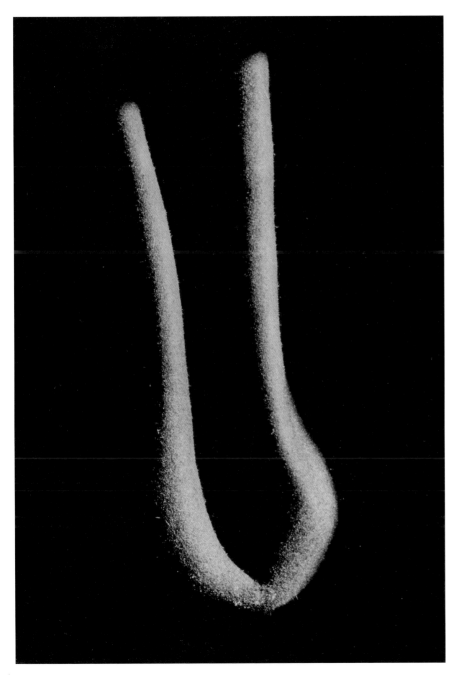

Sunlight shining through a window caught the curving peak of this black stetson hanging in my porch. The stark contrast between the highlighted area and the rest of the hat produced a line that curves back, almost forming an elongated oval shape. As Earth moves around the sun, the changing direction and brightness of light continually causes such designs to appear and disappear, providing photographers everywhere with a constantly changing visual menu.

Who? Where? Why? The questions are not answered, and the viewer is left with the mystery of the unknown. This effect is the result not only of the subject matter, but also of the composition. The placement and size of the chair in the picture space, the amount of empty desert, the visual pull to the distant mist, the oblique orientation of the multi-coloured afghan, even the careful balancing of the amount of sand beneath the chair with the narrow band of mist all contribute.

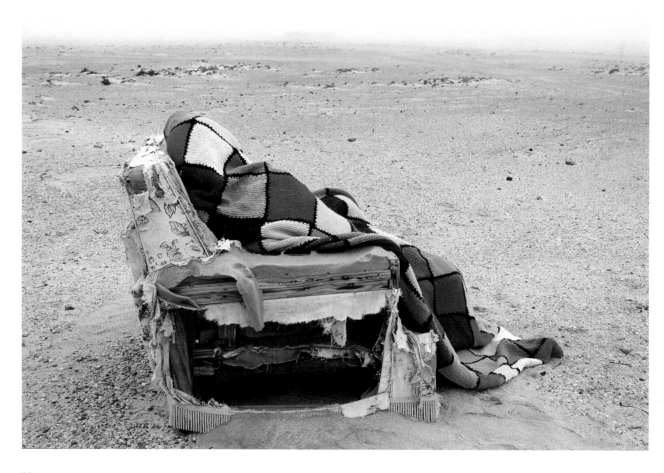

Shape

Shapes, like lines and textures, are made visible or actually created by contrasts of tone and colour. For photographers and others who work with two-dimensional design, the shape of something is its outline or configuration on a flat surface or plane. A shape, then, has no depth. (The term "form" usually implies shape plus depth; it is not a building block of two-dimensional design, but a general term more useful in describing three-dimensional constructions.)

Shapes can be divided into two groups: primary and secondary. When you use one of the three primary shapes – a circle, a square, or an equilateral or isosceles triangle – in a composition in a significant way, you will usually establish a feeling of order and stability. Look at the photograph on page 34 – a church communion plate reflecting the bright colours of a stained-glass window. The colours are fluid, shapeless. They move around on the visual playing field. But the rim and interior circles of the plate provide structure, just like a baseball diamond, containing and focusing the visual action. However, if you give two or all three primary shapes equal prominence in a composition, the visual competition between them may prevent viewers from perceiving any particular coherent theme or message, except for competition.

Secondary shapes, such as ovals and rectangles, and even highly complex shapes such as a maple leaf, are deformations or blends of primary shapes. Unless the overall arrangement of secondary shapes in a composition is very regular, definite, and clear, secondary shapes tend to induce less visual order than primary shapes but may contribute a greater sense of dynamic to the picture design.

To make effective use of any shape, you first must recognize it. That means removing the names or labels from objects and spaces. It means seeing a tree, not just as a tree, but as a triangle, for example. It means being aware that a particular human face or a rock is essentially an oval. This is called "abstracting." As well, it means observing how the shape of a car, a plate, or a lake changes in your field of view as you alter the

Ordinarily we seldom notice the constantly changing appearance of familiar objects –
a jacket, a car door, or, as in this photograph, a church communion plate. But when
we consciously challenge ourselves to open our eyes, to remove familiar labels, we
will discover that the world around us – wherever we are – is as visually exciting as
any place we can possibly imagine.

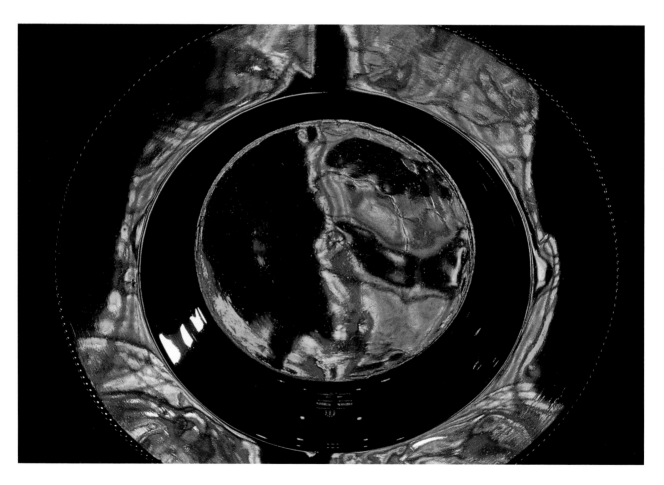

position of your lens, and also how the shape is affected by switching, let's say, from a wide-angle lens to a medium or long telephoto lens. Nearly every change of lens or position of a lens alters the visible shape of an object observed through a viewfinder and thus affects both the information you receive from that object and what you can communicate about it through the pictures you make.

When you aim your lens at any scene, framing all or part of it, you create shapes in your camera's viewfinder that have no counterparts in the world you are photographing. These shapes are often as important to the picture design as any naturally existing shapes. Think of a prairie scene – a vast expanse of golden wheat with an expanse of blue sky stretching upward from the horizon. The land and the sky have no definable shape until you look at them through the viewfinder, thus framing them; then each becomes a rectangle, and basically what you have is a simple composition made up of two rectangles. By tilting your camera upward, you can enlarge the upper rectangle of blue sky while reducing the size of the lower, yellow rectangle. Every tilt up or down changes the proportion of total picture area that each rectangle occupies, and every change is expressive. The larger the upper rectangle, the more you emphasize the sheer vastness of the sky; the larger the lower rectangle, the more you direct viewers' attention to the field and what it contains.

Let's explore this further by analysing the shapes in the photographs on pages 36 and 37. Once you remove the labels from the three main shapes in each photograph, you'll realize that the two compositions are virtually identical – the second being merely an upside-down version of the first. In the aerial photograph the three triangles are clear and distinct. The two black triangles, one in each lower corner, are of about equal importance, balance each other nicely, and act as visual supports for the larger, highly textured, inverted triangle between them. The composition is unified, all parts harmoniously arranged. Now observe that all three triangles in this photograph are formed by sharing one or two of their edges with edges of the picture. I, the photographer, am responsible for that. There were no triangles in the landscape below me. I created them by aiming and zooming my lens, and by pressing the shutter release at precisely the right moment. My reason for this simple, orderly arrangement of shapes was to focus attention on the wonderfully textured appearance of the trees and their shadows in the early morning light.

When I made the second picture, about two years later, I was with several photographers on a workshop/camping trip in Namaqualand. One morning a sudden cloudburst sent us, with our equipment, scurrying for cover. Four or five of us squeezed into a sort of small gazebo. Because the structure had no sides, I encouraged the others to keep on shooting something – anything – and not to be influenced by the notion that wet weather is "bad" weather. We aimed our lenses at the blackened campfire,

This photograph contains three triangular shapes – one larger, two smaller – fitted together to fill the picture space. If you imagine or actually turn the picture upside down, you'll see that its fundamental design is virtually identical to that of the image on the facing page. The main design difference between the two images is in the interior or surface details of the large central triangles. To recognize the building blocks of visual design, you must look beyond the names of things.

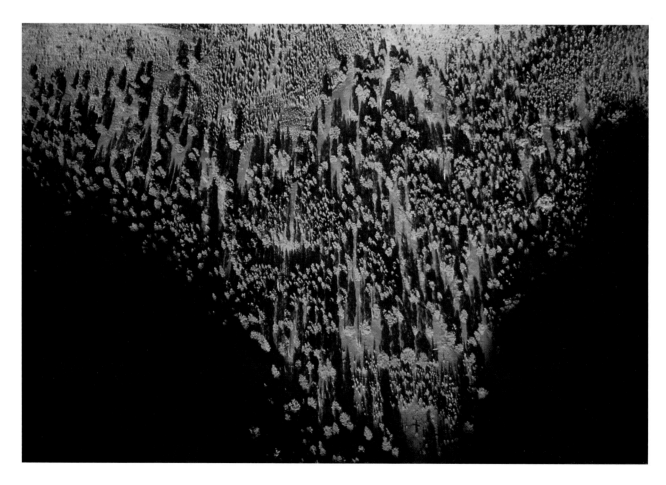

The success of this casual portrait depends on the entire picture design, which is both simple and supportive of its main subject. Other possible compositions, whether closer or farther away, that meet these requirements will give us the same feeling that this is a person we'd like to know. Because situations like this change quickly, a photographer who is skilled in using the visual building blocks will be more likely to capture the moment effectively.

at a pile of soggy canvas chairs, and at water drops streaming down the side of a mini-van; we zoomed our lenses during long exposures and panned our cameras along a row of tents. Suddenly Beverley opened the flap of her tent, looked out at us, and smiled. If I'd had to think, I would have missed the moment, but I'd been practising my visual scales, as it were, so my reaction was instinctive and immediate. Only later, when I saw the transparency, did I analyse what I'd done and why.

This time I created a triangle in each upper corner of the picture space. The location of these two balancing triangles made the remaining space, taken as a whole, also appear triangular, completing an orderly basic arrangement of shapes. As with the preceding image, the large central triangle is where the visual action takes place. Beverley's smile, white sweater, and bright red jacket (all positioned to the left of centre) are attention grabbers, but because I've established a playing field for them, their visual dynamic is contained. We look at Beverley and at the setting, and the shapes keep returning us to her. She is clearly the subject of my photograph.

Not all shapes are affected in the same way by sharing one or more edges with the picture's edges. For example, when a circle (and, to a lesser degree, an oval) meets an edge of a picture and part of the circle is lopped off, the part that remains within the picture space strongly retains its sense of shape, that is, its circularity. The image on page 39 and also that on page 147 illustrate the effect. The first of these photographs contains three circular rocks, all three cut in half by the picture frame. Yet, because of their respective locations and almost equal size, they balance each other, producing a basic visual order that allows us to enjoy, without distraction, the dynamic movement of the water. Triangles and rectangles (including squares) tend to be altered more when they encounter the picture frame. For example, you can make a rectangle into a square (or vice versa) by the amount of the shape you include or cut off, and you can convert both of them into triangles by tilting your camera in a way that leaves only one corner of these shapes remaining within the frame. Also, by tilting your camera, you can make an equilateral or isosceles triangle into a scalene triangle, reducing in the process its potential for inducing a sense of symmetry and order, but increasing its potential for dynamic. However, don't regard the altering or creation of shapes as just an exercise in geometry. What's important is gauging the expressive effect of each alteration – seeing, sensing, and feeling it – so you can choose the effects best suited to your immediate needs and the changes that produce them.

Nearly every composition you make will be a combination of the two types of shapes discussed above: 1/ the shapes of objects and areas that do not touch the edges of the picture but whose configuration you can alter by a change of lens or lens position; and 2/ those that are established in part because one or more sides of the shape are the straight edges of the viewfinder. Since both types affect the overall

We can view this image as a simple study of a natural situation, or we can regard it symbolically. The balanced placement of the three circular rocks brings order to the composition, enhancing our sense of the rocks' stability and relative permanency. A slow shutter speed blurs the water, creating a feeling of dynamic. Balancing these two basic ingredients – stability and dynamic, or order and change – can be as important in creating successful visual compositions as it is in life.

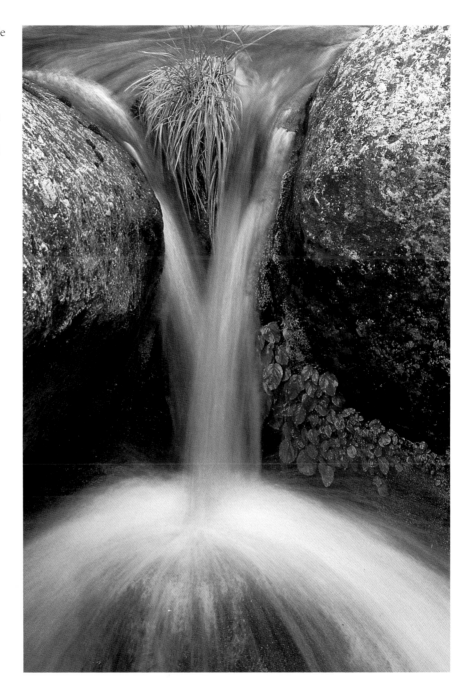

picture design and therefore influence your visual message or statement, you must always make a point of being aware of them and their influence. This is not a difficult task, just a matter of simple observation. The more you consciously pay attention to both kinds of shapes – their configuration, placement, size, etc. – the more automatic the process becomes. You may be surprised to discover that, when observed carefully through a viewfinder, virtually all subject matter from a vast landscape to a tiny flower can be abstracted or seen as two, three, or four main shapes. Once you ascertain what these shapes are, arranging them in the picture space becomes a relatively easy task. Only rarely will the number of important shapes exceed five, and if it does, you should take another look at your composition. The chances are that you are allowing certain details within shapes to confuse your analysis of what the main shapes really are.

The photograph on page 41 is a case in point. When asked to analyse this picture for its fundamental shapes, people commonly reply, "Well, there are definitely three circles (the red fruit of the bunchberries), and there's the narrow, curving shape of the group of white Indian pipes, but the green areas are impossible to describe as shapes because they are so irregular." In my view, the brilliant, highly saturated red circles and, to a considerable extent, the vibrant green and tones elsewhere fool people into thinking that the obvious shapes are the controlling shapes. They aren't. Fundamentally, the composition is a series of concentric circles, indicated by the lines in the accompanying sketch. All these circles are incomplete, being cut by the right edge of the picture and/or the top and bottom edges, but they are still strong enough to function as circles and, thus, to establish the visual unity that produces a sense of order.

You'll find situations and images that are more difficult to analyse for shapes (that is, to abstract) than this one, and sometimes your feelings of frustration will threaten to overwhelm your patience. Take a breather if it helps, but don't walk away from the challenge. Make the best composition you can, and then later on examine your photograph to see if you can discover how you could have improved it. By employing hindsight, you'll gain foresight for compositions you have yet to make. And you'll become aware of important connections between shapes and lines, especially how lines – even invisible ones – create shapes.

Sometimes there's a real difference between the obvious shapes in a picture and the underlying design, which you can see by comparing this photograph with the accompanying line drawing. The strong colour and tonal contrasts, as well as the obvious smaller shapes in the picture, tend to mask the actual composition, which is based on much larger implied shapes.

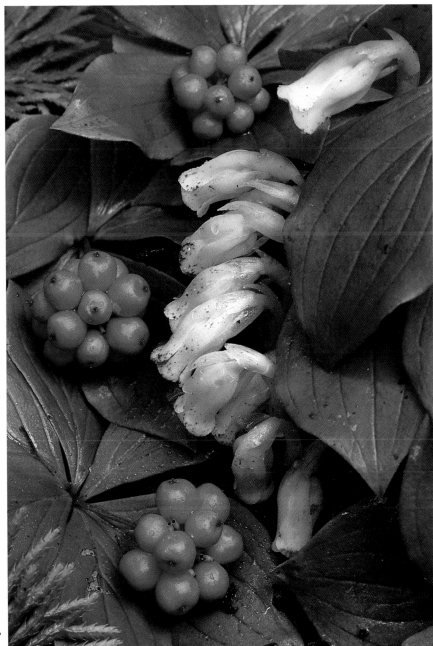

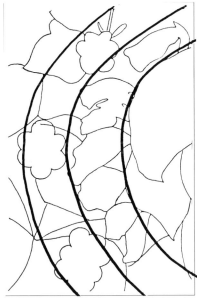

Texture

Texture is the visual building block that photographers are most likely to neglect in creating compositions, even when the texture of a particular surface (ripples on the surface of a pond, the myriad dots of colour in a field of wildflowers, the frayed and faded threads of a pair of old jeans) is what caught your eye or motivated you to stop, observe, and begin to make photographs. In my view, the main reason for this neglect is that textures are internal to shapes, which are easier to see and to place within a composition.

Texture may be defined usefully for photographers in two ways: as 1/ a surface appearance suggesting the weave of a fabric (the texture of ploughed fields, for example); and as 2/ the roughness or smoothness of surfaces. The two definitions are clearly related, as the rougher a surface is (whether the roughness is inherent in the material itself or is enhanced by the intensity and direction of light) the more apparent the weave tends to be. Conversely, the smoother the surface the less apparent its fabric-like appearance.

When the texture of a surface changes (the sand of a beach giving way to an expanse of pebbles, for instance), and you decide to include both parts of the surface in your picture, you are creating an image containing two shapes, the shapes being differentiated or made visible by their respective textures. In short, textures, like lines and edges, can help create shapes or make them visible. So how can you keep the visual emphasis on the texture or textures that motivated you to stop and photograph? When you are working with a single overall texture, the answer is to avoid any object (that is, shape or line) that stands out as a centre of interest and to fill the entire picture area with only the one texture. This advice may seem both simple and simplistic. "That's not composition," you may whisper under your breath. "It's just pointing and shooting." If you think this way, please think again.

Imagine a field of wildflowers at the peak of bloom. Your overall impression is of a vast, multicoloured, multitoned carpet with a billion threads and stitches. Scattered through the field are a few dark green shrubs that command attention because they are so different from the rest of the scene. If your goal is to emphasize the fabric-like appearance of the floral carpet, the first shapes to avoid are those created by the bushes. Move your tripod a little, tilt your camera up or down and from side to side – whatever does the job. Once you have eliminated all the obvious shapes that occur naturally, examine the picture area for less obvious ones that you may have created or missed. Watch out for spots of dark shadow between plants that form definite shapes or lines. Consider whether any of these draw too much attention to themselves. If they do, either eliminate them as well or recompose to distribute them more or less equally throughout the picture space. Scrutinize the entire image area as it now appears in your viewfinder to check the distribution of red, blue, yellow, and orange flowers, green leaves and grasses, highlights and dark tones. If you have a fairly even distribution (no strong clusters of any particular colour or tone), the weave of the field will stand out and make clear why you stopped to photograph. The four photographs of the field behind my house, taken in each season of the year, illustrate these points. (See pages 140 and 141.)

If you are working with more than one area of texture, you will have to decide which area is most important to you or if you want to give each area equal prominence. By moving the camera position or zooming a lens in or out, you can vary the size and placement of the shapes established by the different textures and the viewfinder's edges in order to emphasize one sort of texture or to give all equal prominence. However, keep in mind that the more you can diminish the strength of shapes and lines, the more you will emphasize overall texture(s).

It's well to remember that texture is the appearance of the weave of a fabric, and that this appearance is altered by the distance from which the material is observed. For example, the weave or fabric-like appearance of a forest viewed from an airplane will seem increasingly dense or tight as the plane gains altitude and will appear more open, less tight, as the plane descends. The same changes will occur in the appearance of a lawn – it all depends on whether you are walking across the grass or kneeling on it. Thus, by choosing lenses of varying focal length and by increasing or decreasing the distance between you and the subject matter, you can alter the textural impression.

You can also alter it by the lighting you choose. By employing sidelighting or backlighting, you will usually gain an extended range of tones, including black. Since (with a few exceptions) light tones tend to advance towards our eyes and dark tones seem to recede, the increased contrast will enhance the appearance of surface roughness and define the threads of the weave more clearly. Conversely, frontlighting and the indirect

lighting of a cloudy or overcast day, which reduce sharp tonal contrasts, have the opposite effect. The lighting conditions you choose should reflect the impression of texture that you want to convey. More contrast, like more salt, may overwhelm subtle nuances that appeal to a delicate palate.

You can influence the way the texture of moving subject matter is rendered both by your proximity to the material and by the shutter speed you select. Think again of the field of wildflowers, with all the plants now tossing and swaying in a strong breeze. If you expose the scene at a shutter speed of $^1/_{125}$ second or faster, the chances are that all the plants will appear to be sharp and distinct, as if no wind were blowing. At $^1/_{30}$ second the nearer flowers may be somewhat blurred, but those farther away will still be distinct. At $^1/_8$ or $^1/_4$ second all the plants may lack definition, with nearer ones being rendered as streaks of tone and colour. If you wait until twilight and make a very long exposure, perhaps 30 seconds or longer, the blowing flowers and grasses may appear as a very soft, nebulous tapestry, utterly different from what your eye actually sees. It makes sense to experiment in situations like this so you can anticipate how different shutter speeds are likely to record the surface appearance of various moving objects and materials, such as water flowing, branches swaying, or snowflakes falling against a backdrop of dark evergreens.

Whether your subject matter is moving or not, you can move (swing, jiggle) your camera or use multiple exposure to create textures on film that bear little or no resemblance to those inherent in your original subject matter. These new creations – photographic impressionist paintings, as it were – can be remarkably beautiful and are no less significant because they lack a physical counterpart. (See examples on pages 76 and 77.)

Perspective

In the language of two-dimensional visual design, perspective is the representation of depth or distance on a flat surface. You create, increase, decrease, or eliminate an impression of the third dimension by the ways you arrange shapes, lines, and textures within a picture space. When you arrange them in ways that appear to replicate the three-dimensional world of daily experience, you are likely to communicate with viewers quickly and effectively, which is not to say that is always what you want to do. Sometimes you may choose to ignore or distort familiar visual arrangements in order to create a sense of unreality or to encourage viewers to engage their visual imagination. In short, perspective or the lack of it is neither good nor bad, but useful only to varying degrees. It all depends on how you want to depict your chosen subject matter and what you want to convey about your own vision and feelings.

The quickest and easiest way to create or enhance perspective is to distort or deform space – that is, to enlarge an object or area of your composition relative to another object or area. Imagine a sweeping mountain vista seen from a hiking trail. As you pause, you gaze across an alpine meadow that leads away from your feet to a distant lake and, beyond that, to a range of snowy peaks. The expanse of this mountain wilderness takes your breath away; you want to record the vastness of the scene so you can relive the experience of being here. But when you view the scene through the lens, the sense of space and distance seems to be missing. What can you do to document more accurately what you see and feel?

Let's assume that you have a short zoom lens, perhaps 20-85mm, on your camera, and that when you first looked through the viewfinder you were standing at your normal height. From that position, the best composition seemed to be with the lens set at about 65-70mm. To improve on that (that is, to express both the physical fact and the feeling of distance more effectively), you have to deform space by doing three things more or less simultaneously. 1/ Zoom your lens back to a short focal length,

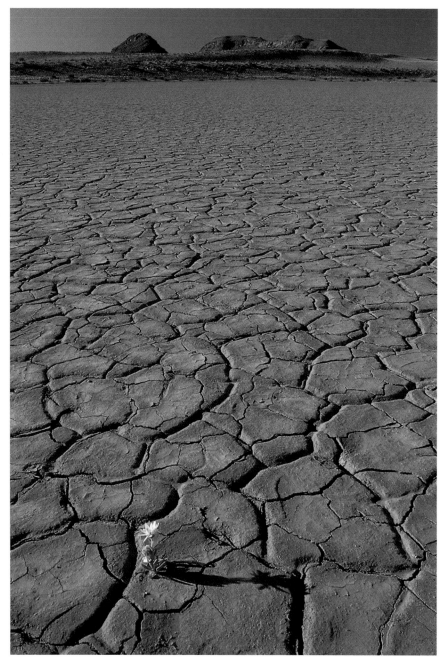

The relationship between an object and its environment usually interests me as much as the object itself, which is why I was attracted to this tiny plant eking out an existence on a dry lake bed. By positioning a 24mm lens about 10 cm above the cracked mud and tilting it down to include the plant while retaining a sliver of sky, and by using maximum depth of field, I was able to show the plant close up and convey the extent of its barely supportive environment.

say 20 or 24mm. 2/ Lower your camera much closer to the ground and tilt it sharply downward. 3/ Move in closely on some foreground object such as a small clump of flowers or a few pebbles, which will now be greatly enlarged relative to the lake and mountains. This deformation will cause viewers to "see" the distance, because it is similar to what we all experience in our three-dimensional lives, where we have learned that an object we know to be small (a flower) must be nearer to us than an object we know to be large (a mountain) whenever the small object appears to be larger than the large object.

A wide-angle (short focal length) lens produces the greatest sense of depth in a scene when the camera is positioned vertically, is very close to but above a significant (but often very small) foreground object and tilted downward, and when the lens is set at its smallest aperture for maximum depth of field, as on page 46. Assuming a more or less continuous plane from foreground to background, you can ensure that all parts of your picture are in focus by setting the lens at its smallest aperture and focusing on whatever subject matter is one-third of the way up the picture space from the bottom. Since the depth of field in a photograph is twice as great behind the point of focus as it is in front, this will render everything in focus from foreground to background. (Very rarely will you be in a situation where material at the top of your composition is nearest to the lens and material at the bottom farthest away. In such a circumstance, focus on whatever subject matter is one-third of the way down the picture space from the top.)

The other exception to this guideline is when the material nearest the lens is on the left or right side of the picture space, not at the bottom, perhaps when you are shooting along a fence or wall, as I was for the smaller picture on page 48. In this case, I focused approximately one-third of the way along the wall from the left side (foreground) of the picture and set my lens at its smallest opening, f/22. However, I was using a 135mm lens, and I was not as near to the wall as I could have been. Consequently, although space is deformed (notice the diminishing size of the windows from left to right), it is not nearly as deformed as it might have been, and the full potential for perspective has not been achieved. Whether or not I made a good decision by using the lens and camera position I did is up to each viewer to decide.

The larger photograph on the same page evolved from the smaller one, which I also made from the rear of the church. As I stood there, I wondered how a church mouse might experience space inside this edifice. (A good way to stimulate new ways of observing things is to pretend you are someone or even something else.) Of course I soon concluded that, because a mouse is much smaller relative to the church than I am, it might regard the building as being truly enormous. In order to convey this impression, I kneeled down on the main floor, switched to a very wide-angle lens

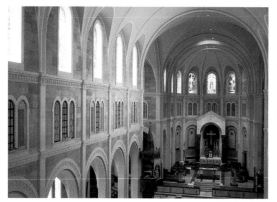

There is nothing sacred about normal human perspective. Other creatures that share our world see it very differently than we do. Looking through a viewfinder while pretending to be a mouse or a dog, for example, can be a visually and mentally liberating experience. Comparing these two photographs of a church interior – the smaller from a typical human point of view, the larger from a mouse's – makes the point.

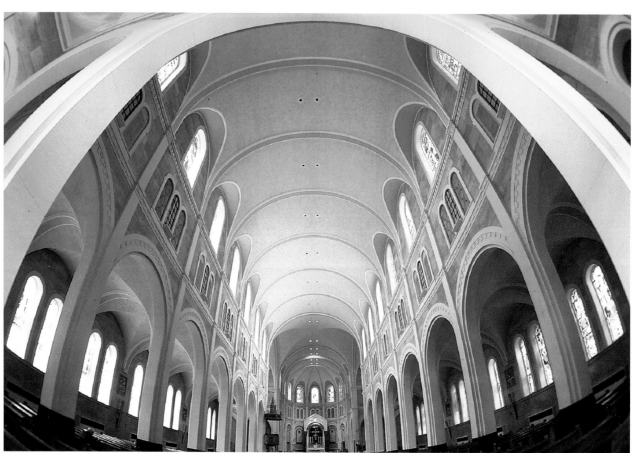

(17mm), placed the camera on the floor at the rear of the centre aisle but tilted it up at a sharp angle, and made the photograph reproduced here.

Photographers who want to achieve full depth of field – whether the material nearest to the lens is at the bottom, top, or one side of their composition – are often told to focus one-third of the distance "into" the picture space. This is erroneous advice. Think about it for a moment. If the nearest object in your wide-angle composition is 20 cm from the lens and the farthest is at infinity, one-third of the distance into the picture space is also infinity. If you focus there, all the foreground will be out of focus, even at the smallest lens opening. To reiterate the correct approach: if the object nearest to the lens is at the bottom of your composition, focus one-third of the way up the picture space; if the nearest object is at the top, focus one-third of the way down; if the nearest object is at either side, focus one-third of the way along the picture from that side. In all cases use a small lens opening.

To return to the mountain vista and other expansive earthscapes, it always makes good sense to consider whether or not you want to include some sky in your composition and, if you do, to think carefully about the amount. Remember that the horizon is the place where wonder begins. Because you can't see what lies beyond it, you are "lured" to it. This adds a psychological experience of distance. If you eliminate the sky entirely you eliminate the horizon, and you lose that experience of being lured. On the other hand, if you include a lot of sky (especially a solid blue or grey), you create a powerful shape, usually a rectangle, that sits at the top of your picture, "squashing" the sense of depth. However, if long "mare's tail" clouds form lines in the sky that complement lines in the land below, you may want to include them. Every situation is unique, challenging you to assess the visual building blocks and to exercise your judgement about arranging them in ways that will produce more or less perspective.

There will be times when you will want to reduce perspective, perhaps because the representation of depth conflicts with your planned geometric arrangement of shapes and lines. By selecting any camera position and/or lens that makes a deformed shape look less deformed, you will appear to flatten perspective. Generally, this means using longer lenses rather than shorter ones and elevating your camera to avoid foreground material – the reverse of what you would do to increase perspective. The aerial photograph of Australia's Great Barrier Reef on page 50 illustrates this technique clearly.

Our perception of depth is also influenced by the ways that light – its intensity, quality, direction, and colour – illuminates subject matter.

Because there is nothing in this image to provide a sense of scale, because it lacks any real sense of depth or distance – in short, perspective – viewers respond to the lines, shapes, and textures created by contrasts of tone and colour, and to the dominant rich turquoise hue. Although I identify the subject matter in the text, I hope you will respond here to the visual arrangement as a thing-in-itself – without trying to pin a label on it.

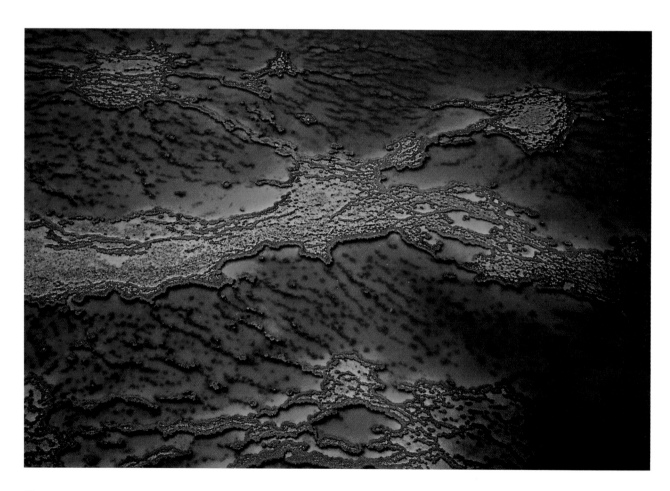

1 / The intensity or brightness of light varies within the picture area, and this contrast aids our perception of depth. A light object will tend to appear closer than it actually is; a dark object will appear to be farther away.

However, there are some important exceptions. For example, a series of hills or mountain ranges, such as those shown on page 52, appears progressively lighter in tone the farther away they are, due to atmospheric haze, which reflects light. Also, a small area of dark or light tone will appear to come forward when surrounded by a strongly contrasting tone. The amount of contrast, the position of tones within the picture space and in relation to other tones, and the size of the area occupied by particular tones are all important to the rendition of perspective.

2 / The quality of light affects perspective. The more direct the light source, the harsher the illumination, and the more abrupt the tonal contrasts within the picture. Harsh light enhances depth perception, except when it falls so directly on the front of an object that it creates no shadows (that is, no contrasting dark tones). For example, if the surface of an object is rough, the texture is likely to be shown more realistically when illuminated by harsh, direct light rather than by soft, indirect light. The soft light of a cloudy day or reflected or "bounce" flash eliminates shadows that create perspective.

3 / The direction of light has a very strong influence on perspective. Frontlighting, however strong, tends to flatten perspective by eliminating tonal contrast, because the shadows may all fall behind the subject matter. Backlighting can suggest perspective by creating shadows that fall towards your camera, providing both contrast and lines, which in turn imply distance. However, in some situations backlighting can eliminate perspective. For example, a human head viewed from in front becomes a two-dimensional silhouette when it is backlighted and tonal variation is obliterated within the face itself, which becomes all black. Sidelighting creates perspective with shadows that accent texture and provide tonal contrast. However, if you are photographing horizontal bands of shadow — created, let's say, by the sun sidelighting a row of trees — you will sense depth only if the shadows become progressively narrower from foreground to background. In other words, the diminishing size of the shadows is as important as the sidelighting that caused them. The strongest impression of depth is created by light that enters the picture space from any corner, because it can form the longest oblique lines possible, as shadows. Oblique lines often appear to lead from foreground to background, or the other way around, thus suggesting depth.

4 / Colour affects depth perception. Under daylight conditions, warm colours seem to come forward; cool colours seem to recede. From the same distance, a bright red object will seem nearer to the viewer than a bright blue one. Also, saturated hues

I made this picture of a mountain range in South Africa one morning when the sun was still low in the sky, just outside the picture frame. The increasing faintness of the mountains the farther away they are from the viewer shows how air particles, particularly when backlighted, help us perceive perspective by making more distant objects appear fainter than those closer to us.

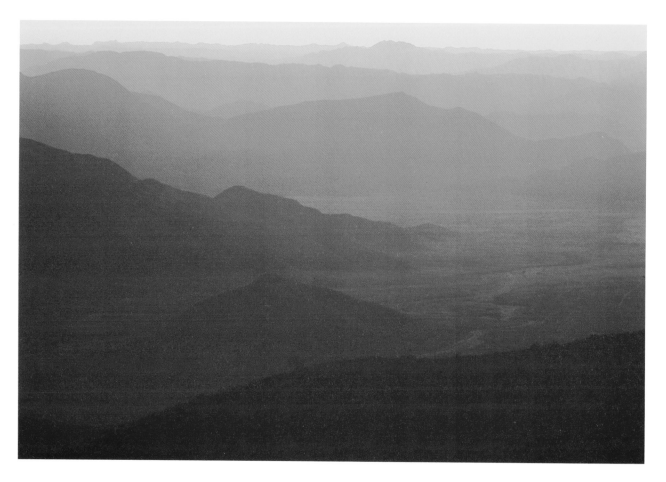

such as pure red will seem to be closer than the same hues in a less saturated condition (pink).

There are other variables that influence the creation and control of perspective. Although they are considered here apart from light, they may be affected by the intensity, quality, colour, or direction of light.

1 / Sharpness. Clearly defined or outlined objects will seem closer than objects that – because of focus, haze, or other natural factors – are not as sharp. For instance, a leaf in focus usually seems nearer than one that is out of focus, even when the out-of-focus leaf is actually the closer of the two. It is sometimes difficult to determine relative location, and optical illusions may occur, as out-of-focus objects in the foreground seem to recede.

2 / Size. Generally speaking, the larger an object is, the nearer it seems to be, especially in relation to smaller objects of identical or similar shape. This perception is based on our daily experience. Relative size, or scale, suggests distance very strongly indeed, and it is difficult for a photographer to find a situation in nature where this does not occur. Sometimes, however, a photographer will want to introduce an object into a picture in order to add scale and increase the sense of depth. If the prairie road disappearing into the distance does not give the intended illusion of depth, the photographer may wait for a car to appear on the distant horizon. The tiny size of the car enhances our perception of distance. This is a good technique as long as the added object does not destroy the theme of the picture. A person in a wilderness scene may add needed scale, but may also destroy the sense of wilderness, especially if she or he is wearing brightly coloured clothing.

3 / Placement or location. Because the lower half of a picture often tends to command more attention and seem nearer than the upper half, objects located in the lower half usually appear closer than those in the upper half. This, too, corresponds to real life – near objects are usually lower in space than far objects. Naturally, an object that is located in front of another object will appear to be closer, because it is closer. This is called overlapping and is often a key factor in creating perspective. We perceive overlapping even when the foreground object is smaller than the one behind it.

4 / Obliqueness. As noted earlier, oblique lines and shapes appear to be unstable, rather like horizontal or vertical ones knocked out of position. They make a composition appear dynamic by adding tension. Tension suggests movement, and movement suggests space through which to move. Oblique lines also lean forward or backward, although on the flat surface of a photograph an oblique line can only point upward or downward. We simply transfer what we observe in real life to our understanding of space in a photograph. This adds to the illusion of depth in a picture.

Light, deformation, and the other variables all affect how you perceive depth in photographs. But you do not have to be concerned about them all the time; perspective generally takes care of itself. Only when you feel that the sense of depth is misleading or that a picture could be improved by increasing or reducing perspective should you employ the techniques I have mentioned. Try examining some of your photographs to see how changes in light, deformation, and other variables could have improved the desired sense of perspective. However, don't let the abundance of information on perspective overwhelm you or inhibit your photography. Use it with confidence, but only when you feel it is an important element in your composition.

When I was very young, an aunt gave me a set of building blocks made of wood. I was delighted with them, and after a little initial guidance I was arranging them side by side and on top of each other, using the blocks and my imagination to create my own personal designs. That's what I hope you'll do now – use the building blocks of visual design to create expressive images that are uniquely your own. In the following chapter I'll help you get started, but you must do the building.

Putting the building blocks together

Once you are familiar with the main building blocks of visual design, you'll want to do some building – to make photographs rather than simply to take them. That's what this chapter is about – learning to arrange lines, shapes, textures, and perspectives in ways that produce clear visual documents, arouse emotions, or convey ideas.

The first thing to be aware of is that there are, or should be, no rules of composition, just principles and guidelines, for good picture organization. By relying on your imagination and common sense as you evaluate, adapt, and use these guidelines, you will respect and honour the unique character of your subject matter, whatever it may be, and the unique character of your response to it. Sure, you'll make lots of weak or ineffective compositions at first, but you'll be learning and growing, which never happens when you rely on rules.

In virtually every image you create, you'll want to establish some degree of order or structure: more, if the subject matter is orderly by nature, or if you want to convey a sense of order for a personal reason; less, if the scene is more random in appearance or you want to express a sense of fluidity, movement, or even chaos. Think of a continuum between perfect order at one end and complete chaos at the other. Every composition you make will fall somewhere between these two extremes, and it's up to you to decide where.

Generally speaking, the more simple and orderly a composition is the more quickly and effectively it delivers your message. In this respect, the language of pictures is like any language of words. However, a visual composition that is simple in its basic arrangement or structure may have a great deal of surface complexity that adds visual

richness and meaning. For example, the careful juxtaposition of two triangular objects in the picture space may induce a strong sense of order, but colourful textures or oblique lines within those shapes can relieve any feeling of formality or rigidity caused by the basic arrangement. Thus, while such a composition may be simple, it will not be seen as simplistic.

Recognizing and arranging lines, shapes, textures, and perspectives in order to convey a visual message effectively is a challenge that can bring lifelong satisfaction. To meet that challenge, you may use any or all of four important principles of picture organization – dominance, balance, proportion, and rhythm. By adapting and using these principles or ways of arranging the visual building blocks, you can achieve the degree of order most suitable for conveying your message or theme.

Dominance

Dominance usually means that some aspect of a composition influences the entire composition more strongly than all the other aspects. The dominant part of a photograph is often called the centre of interest or major motif. It may be dominant because of its size, colour, location, symbolic value, or any combination of these and other factors. For whatever reason, it acts as a point of visual emphasis or rest, giving a sense of order and stability to the composition.

The example on page 58 contains a large blue rectangle and two long, narrow white rectangles. At precisely the point where all three rectangles meet, there is a black oval. The oval – a man's head – is so different from the other three shapes and so strategically placed that, despite its small size, it draws an enormous amount of attention to itself and has the effect of tying the rectangles together. It unifies the composition.

If I had tilted the camera downward and to the right, I would have increased the size of both white rectangles while decreasing the size of the blue rectangle. In such a composition the interior details of the white rectangles would compete for attention with the black oval, leaving viewers feeling uneasy about the lack of a clear visual statement. They might wonder whether I intended them to concentrate on the man and his dreaming posture, or on geometric patterns in the fence and building. My reason for rejecting this alternative and creating a simple, unified composition was the subject matter and my response to it. When I noticed the young man nodding in the shade of the building beside a picket fence, I sensed his desire to be left alone, his reverie uninterrupted. By including the shape of his head, I drew attention to him; by creating large spaces around him, I showed my respect for his privacy. And, by placing his head so strategically, I tied the two ideas together visually.

This is a simple, orderly composition – three rectangles and an oval. The oval dominates or acts as a centre of interest because it is the only dark tone in the picture space, because it is placed so close to a corner and at the point where all the rectangles meet, and because we recognize it as a person's head. Using one visual building block to tie all the building blocks of a picture together is one of several good ways to create visual order and harmony of impression.

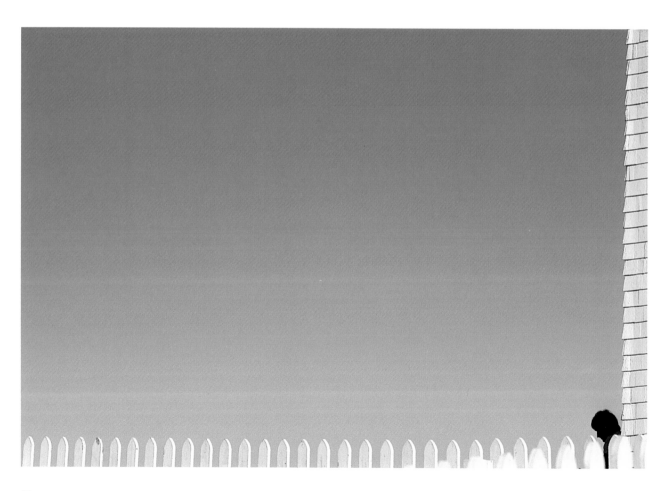

Sometimes, a line or shape used as a point of dominance or centre of interest commands so much attention that viewers tend to become fixated on the one spot. In order to generate a sense of dynamic or at least some feeling of movement, it's often useful to recompose a picture to include a secondary shape or line that competes mildly for attention with the main one. In some cases two, three, or several secondary motifs are better than just one. Consider the picture on page 60. One morning while I was shaving, a moth settled on the outside of my bathroom window; I immediately put aside my razor and set up a tripod, camera, and 100mm macro lens. No matter how large or small I made the moth or where I located it in the picture space, it drew so much attention to itself that the composition seemed static – until I found a position that enabled me to pick up numerous small spots of black tone in the bottom third of the image. These tiny areas of black act as a secondary motif by competing gently with the black tone in the body of the moth, thus inducing eye movement and adding a subtle dynamic to the composition that is in keeping with most people's feelings about moths. (The top photograph on page 123 illustrates the use of a more obvious secondary motif.)

Not all pictures benefit from the presence of a centre of interest, and a great many are spoiled if they have one. This is especially true when all parts of the subject matter, viewed as a whole, form a pattern or texture that is visually more arresting than any of its individual parts. For instance, if I had included a rock or a person in the picture on page 61, the shape would have drawn considerable attention to itself, thus diminishing or even destroying the overall impression of the colourful field, which to me was the real centre of interest.

Even when you use a centre of interest to make a composition appear orderly and unified, you will often employ other methods simultaneously. None is more important to visual compositions and to the resulting expression than the principle of balance, which we'll consider next.

Why do we so often regard familiar things as having little value until somebody else assigns them worth by drawing them to our attention? Perhaps the best way to challenge our preconceptions is to explore several familiar objects or situations – a plate streaked with egg yolk and bacon fat, puddles of water in a driveway – with our cameras. In this case, the moth on my bathroom window seemed insignificant until I made it the dominant element in my picture.

Texture, the weave or fabric-like nature of surfaces, can be very compelling both visually and emotionally, but of all the visual building blocks it is the one most often neglected by photographers, who find arranging lines and shapes much easier. However, by carefully avoiding every line or shape that tends to act as a point of emphasis or centre of interest, a photographer can make the overall tapestry of a field or other surface the dominant visual element of an image.

Balance

When you feel that a composition "looks right," even if you aren't quite sure why it does, the chances are good that you have balanced the various picture elements in ways appropriate to both the subject matter and what you want to communicate about it. Since you maintain your own physical balance by constantly scanning and interpreting the location of visible objects in the world around you, you have a gut instinct about whether or not a composition is well balanced. Generally you should trust this instinct. However, if you can bring to conscious awareness what you already sense or know subconsciously, you'll be in a much stronger position to use balance as an effective tool of visual expression.

Every visible object attracts attention by its tone, colour, shape, size, location, or other physical properties and characteristics. The degree to which it attracts attention is known as its visual importance or weight. Competition for attention between objects of similar or differing weights, called tension, keeps our eyes constantly moving so our normal visual experience is dynamic. Photographers modulate and control tension by the way they balance objects and spaces (that is, lines and shapes) within a picture space. Good balance usually means taking advantage of tension without letting the visual pull of any one object get out of control.

There are basically two ways of balancing lines and shapes in a composition – symmetrically and asymmetrically. (These are also referred to as formal and informal balance, although the terms are not quite synonymous.) Everything in a symmetrical composition is organized around a central vertical or horizontal axis, with all the lines and shapes on one side of the axis being identical or nearly identical to all the parts on the other side. Thus, each side has the same visual structure and weight. Almost without exception, this sort of arrangement is possible only when the subject matter, viewed from a given point, is itself symmetrical. The interior of many cathedrals and churches looks symmetrical when you stand in the centre aisle and point your lens

directly at the altar. (See the larger picture, page 48.) The sides of many buildings can be presented as symmetrical compositions; imagine two identical windows, one located in your viewfinder to the left of the central vertical axis and the other positioned in exactly the same way to the right of it. Such formally balanced, symmetrical arrangements of visual building blocks always produce a strong impression of order and stability. The large red triangles of the cover image also illustrate this.

In many instances a symmetrical composition seems so ordered and static that it almost cries out for imbalance – something to relieve the visual monotony and add dynamic. Think of such situations not as problems, but as opportunities. For example, by your choice of lens and camera position, you can create an arrangement that is symmetrical overall in order to call attention to one shape or line that cannot be fitted into the symmetry. The image on page 64 illustrates this clearly; the shadow of the flag is strongly emphasized because it is so different from the rigid, symmetrical presentation of the building and sky spaces.

The picture of women approaching a church (page 65) is a complex variation of the preceding composition. Again, the building façade is balanced symmetrically, producing strong, basic order. The women add dynamic, not confusion, but only if the shutter is released at precisely the right moment. ("Good timing" means waiting for moving objects to arrange themselves in an expressive design.) The woman on the left is nearer the camera and therefore larger than the woman on the right. However, because she is wearing a paler pink dress and because the lower part of her body is not included in the picture, she commands only slightly more visual attention. The small deficiency in the "weight" of the woman on the right is compensated for by the presence of the rectangular white hymn sheet that stands out strongly against the blackness of the open door. So the net effect is one of almost perfect left-right balance, but it is informal, asymmetrical balance that gives the picture life and movement.

The urban image on page 66 is completely lacking in symmetry, but it is well balanced. The area of dark blue sky at the top and the area of even darker blue water at the bottom are only roughly similar in shape, but they are of almost equal size and visual weight. Neither, therefore, is more important than the other. As a result, our attention is focused on the very different central area of lighted streets and buildings, which is the main subject.

Sometimes you will want to balance a small object with a much larger one, both objects being important to the composition. Usually the solution is to place the smaller object in an extreme position, that is, close to an edge or corner of the picture, where it exerts more "pull." At the same time, locate the larger object in the centre of the space or near to it, but tending slightly towards the edge or corner opposite the small object.

A few moments earlier or later, the shadow of the flag would have fallen elsewhere on the front of the building, but at this moment its position provides visual relief from the symmetrical balancing of shapes that makes the composition so orderly. Or, to put it another way, the formal arrangement of shapes gives the shadow its importance. Good timing is rarely a matter of luck, but of recognizing when certain design elements work well together.

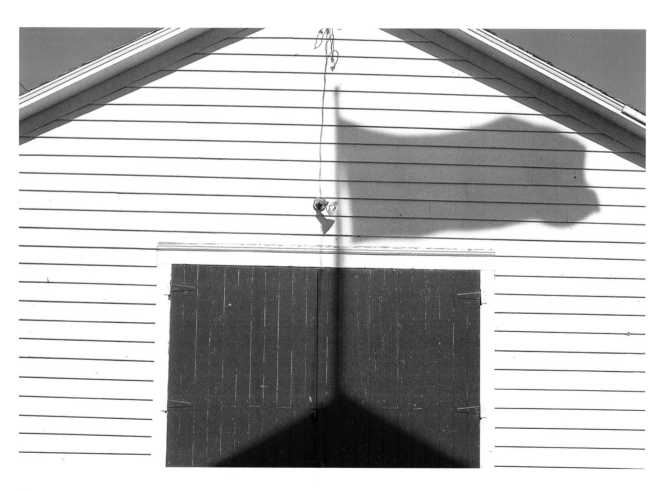

The composition of this photograph is similar to that of the preceding image in the highly symmetrical presentation of the building. However, the colours in the two pictures arouse quite different feelings. Here the warm pinks of both the clothes and the church strengthen the tangible and intangible connections between the women and their church.

A well-designed photograph enables viewers to respond more easily to the subject matter, whether it is recognizable or not. Here, the careful but informal balancing of the sky and water areas focuses attention on the central part of the image, while tying everything together in an overall impression of a city at twilight. I checked several viewpoints earlier in the day and, after deciding on this one, returned at sunset to watch the changing light. I made this picture about 30 or 40 minutes later.

It's important to remember that balance often depends on psychological factors as well as on physical ones. What you know or feel about something can add visual weight to it, and you have to consider this as you arrange the picture elements. For example, a boa constrictor curled up on a living-room rug will command far more attention than a dog sleeping nearby, even if both occupy relatively the same amount of picture space. If you substitute another dog for the boa constrictor, you will reduce the psychological tension and may well have to alter your camera position in order to achieve a well-balanced composition. Or, to provide a very simple example, the psychological impact of different colours influences balance. Two blue triangles of identical brightness, colour saturation, configuration, and size will balance perfectly, whereas two triangles of identical brightness, saturation, configuration, and size will not balance perfectly if one is blue and one is red. Red has more visual weight than blue due in large part to its greater psychological impact.

Direction influences balance, even when the direction is implied rather than being actually visible. Include a person anywhere in a scenic composition, and the balancing of objects will be altered every time she turns her gaze or tilts her head. The implied line of sight exerts a visual pull that has definite expressive power. Assume a tree is standing near the left edge of the picture space, and the person somewhere to the right of centre. If she looks to the left, she increases the visual weight of the tree; if she looks to the right, she reduces its importance – even if the tree is very large and the woman very small by comparison. Even if you love trees, as I do, you will assign more psychological weight to the person than to the tree, adding strength to the direction of the implied line of her gaze.

Appropriate balancing of lines and shapes, real or implied, is a critical factor in achieving expressive visual order in the vast majority of compositions. Regard the information and suggestions I've provided only as helpful starting points or guidelines, and don't feel constrained by them. Achieving good balance in your pictures, as in your life, is a matter of valuing the principle while adapting it creatively for application in a multitude of different circumstances. Also remember the exception; there are times when, for good purpose, the last thing you want to do is lead a balanced existence or create a balanced composition.

Proportion

Proportion has to do with the relative size of objects in the picture space. It is closely related to balance, as the amount of space allocated to a major object or area, in relation to that allocated to a minor one, can determine whether pictorial balance is satisfactory.

Proportion has an enormous capacity to influence our understanding and to generate feelings about both an entire composition and its component parts. Look at the photograph on page 69. Initially I used a 300mm lens in order to fill the frame with the shape of the tree. It was a clean, well-balanced composition, but not very interesting, and failed utterly to convey my feelings about the tree and its situation – because of the proportion of picture space occupied by the tree relative to that occupied by the sky.

Trees are social creatures. Left to their own devices they establish communities with a vast and intricate network of relationships; they compete for space, for light, water, and soil, but they also co-operate with each other. A community of trees can retain more moisture than the same number of trees can retain as widely separated individuals. Collectively, trees enrich whole areas of soil by shedding dead leaves and branches, which are converted to humus, nourishing succeeding generations of plants and animals – and much, much more. So when I saw this tree standing by itself on top of a hill, I was struck by its forced isolation (the rest of the tree community having been cut down by a sheep farmer), and I felt great loneliness. Yet I also sensed tenacity and dignity. To convey these different impressions, I decided to position the tree near the bottom of a vertical composition and to keep it very small in relation to the amount of sky. The larger I made the tree relative to the sky, the more I diminished its isolation and my feelings of its loneliness, tenacity, and dignity.

Since the total amount of space in your viewfinder remains constant, by reducing the size of one object or area in a composition you necessarily increase the size of another – the less space the tree occupies, the more space the sky takes up. Such a change can be enormously expressive, altering the information, idea, or feeling a picture conveys.

For similar reasons I kept the flowers very small in relation to their rocky habitat in the photograph on page 71. To have done otherwise would have been to reduce the visual effectiveness of the nature story.

The sky area of the image on page 72, also occupies most of the picture space, but for precisely the opposite reason. The colour and soft detail of the clouds were so compelling that I wanted to show an expanse of them. The sand dunes replicated in reverse the general shape of the cloud bank and gently reflected the warm, pink light, thus acting as visual support for the main subject. But to have included more of the dunes would have been to turn support into competition.

Obviously, assigning objects or areas more or less of the picture space often requires thoughtful judgement. Your guides should be the subject matter, how it makes you feel, and any information or ideas you want to convey about it. If you are unsure about what works best for you, keep changing your camera position and/or the focal length of your lens until the sizes of the various lines and shapes feel right. Later, when you look at your slides or prints, you can analyse what you did and draw conclusions that will help you with future compositions.

Lichens growing on the rock slow down the passage of air, allowing dirt and seeds to collect in the crevice. Morning mists create water drops that trickle into the crevice, moistening the dirt and causing a seed to germinate. The rock face shades the crevice, preserving the meagre water supply so the tiny plant can grow, flower, and set seeds. When the life cycle is completed the little plant dies, its remains enriching the soil for future generations. Only a composition that portrays the plant as being small and the habitat large can hint at the nature story.

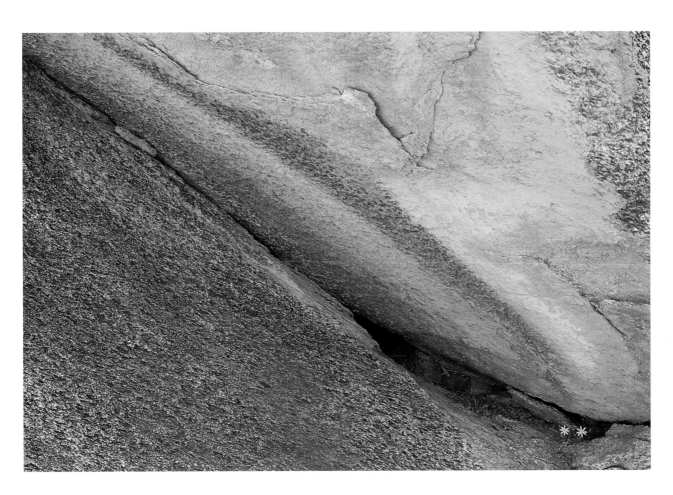

Nearly every problem has a silver lining – or, in this case, a rosy-orange one. While I was photographing on the far side of the largest dune, my tripod fell over and the camera jammed. It took me over an hour to walk back to my van, get another camera body, and return to the area. But I never made it back to the original spot. The setting sun began to colour the clouds and warm the dunes, arresting me in my tracks. If I hadn't had the accident, I would never have made this photograph.

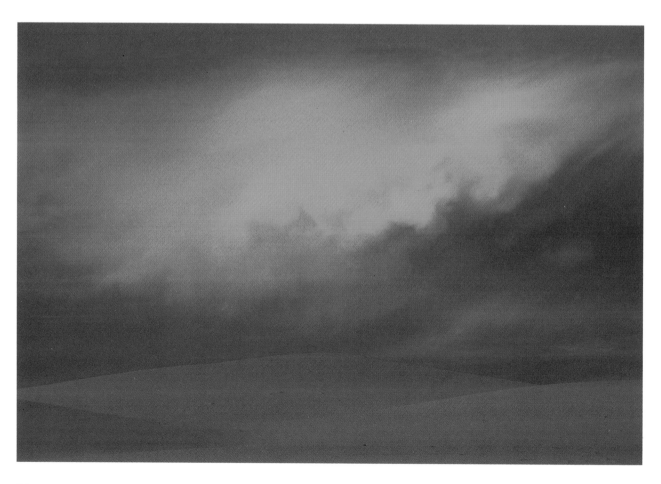

Rhythm

Rhythm is more than repetition. It is a harmonious pattern characterized by the regular or predictable recurrence of strong and weak elements, usually lines and shapes. As in music, rhythmic arrangements are both orderly and dynamic, providing overall structure on the one hand, and a feeling of movement on the other. The compositions on pages 27, 29, 74, 133, and 155 all depend on rhythm.

Sometimes the rhythmic nature of a scene, perhaps a row of corn stalks (vertical light lines alternating with dark spaces over an extended space), will attract your attention, encouraging you to stop, to appreciate, and to make photographs. In such situations it makes sense to use the naturally occurring visual rhythm as the basis of your composition. Other times, when the subject matter has little or no inherent rhythm, you may select a certain camera position in order to align shapes rhythmically in your viewfinder. The visual order and dynamic you achieve by doing this should be in keeping with your feelings about the subject matter. Let's look at an example of each approach.

The regularly alternating bands of light and dark tones in the stone steps (page 74) form a strong rhythmic pattern when viewed from almost any position. The plants growing among the stones show much less rhythm and have the effect of slowing us down somewhat as we climb, visually, up the steps. In my view, the inherent structure of this particular situation was appropriate for my composition.

The smaller of the two photographs on page 76 shows the material I was working with – three pitchers of coloured water. By moving the pitchers around in relation to one another and by observing them with a 100mm macro lens from all sorts of angles, I was able to create many interesting images that had no actual physical counterparts. Although I spent five days working with these pitchers (and could easily have spent five weeks), the larger image is one that I made several hours after I first began. It illustrates rhythmic arrangement created primarily by my choice of camera

Often the inherent design of your subject matter can form the basic design of your photographs, especially when your intention is to document a scene, situation, or object. For example, in this situation the alternating bands of light and dark tones that give the steps their rhythmic appearance also give the composition its orderly structure, enabling viewers to enjoy the more informal arrangement of flowers all the more.

position, and it required me to scrutinize every line, edge, and shape. The most minor adjustments in the camera's height, tilt, and distance from the pitchers affected the pattern, often significantly, as did slight alterations in focus and depth of field.

The order in rhythmic compositions comes from the innate balance of recurring lines or shapes, the sense of movement from the fact that no one line or shape is strong enough to arrest the viewer for long. As a result, many rhythmic compositions are easily seen or grasped "whole."

Sometimes you may want to use a rhythmic pattern in conjunction with a line or shape that is very different, such as a rock standing in front of a background of waves (alternating white and blue bands) or an insect resting among the radiating growth lines of a tree stump. Because the rhythm contrasts so strongly with the single, unrepeated shape, it gives added dominance to that shape. This is especially true when the different object is relatively small in the picture space.

It's worth noting, in conclusion, that just about everybody finds rhythm pleasing, whether in music or in pictures. So when you are thinking about the best way to arrange your subject matter in a picture, you may want to take advantage of this general human response by employing rhythm. It's always easier to deliver a message to a receptive audience.

The visual building blocks you select and the arrangements you create with them will depend on what you intend to document, describe, or convey. As an instructor who respects your ability to feel and think for yourself, I have the task of providing raw materials in the form of clear, accurate information about design that you can consider, adapt, and use to achieve your visual goals. Your challenge is to create.

Don't be discouraged if your initial efforts and many subsequent ones are less than what you hoped. All the information in the world about how to drive a car won't make you a good driver. There's a process you have to follow: first, you learn basic information about operating a vehicle; second, you turn the ignition key; third, you release the clutch or engage "drive" to start the car moving. After that, it's "practice and more practice" until you develop skills and reflexes that make you a safe and confident driver. It's much the same with creating well-designed, expressive photographs – an instructor can teach you the basics and assist in your progress, but only you can "drive the car."

This study in rhythm is a project for a rainy day – or any time you find yourself thinking that there's nothing much to see around your home. Fill three clear glasses or pitchers with juices or coloured water, place them close together in different positions, and explore the ways the colours mix visually. You'll need a macro lens or other close-up equipment. (A fourth pitcher containing clear water will mix the colours of the other pitchers best of all.)

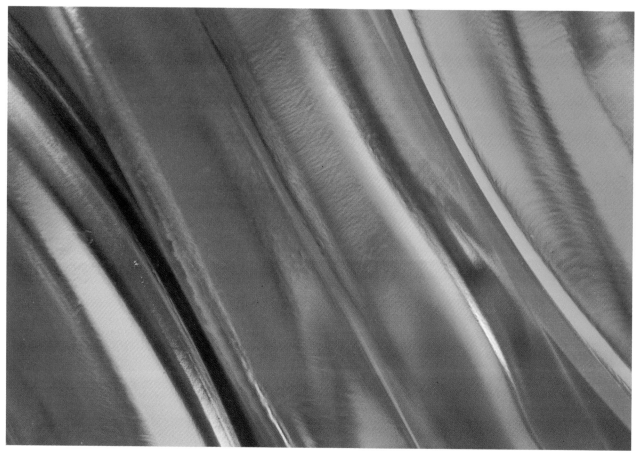

The simplicity and order of this composition are provided by rhythm, dominance, and balance. The fence has an internal rhythm of alternating light and dark lines that moves us from left to right, but it also forms a dark band in a pattern of alternating light and dark areas from top to bottom. The arhythmic bush, which acts as a point of visual emphasis, is balanced by the fence, especially by its highest point in the upper left.

Evaluating your photographs

In my workshops, part of every day, except for the first and last, is set aside for evaluating photographs that participants made on field trips the previous day. Each student selects three or four photographs for inclusion in "the evaluation," so everybody sees and hears comments on 45 to 60 images. Before the first evaluation, first-time workshop participants are often apprehensive, but their fear soon dissipates. My teaching partner and I take turns; he comments on one picture, and I on the next. We make our remarks as relevant, constructive, and succinct as possible, and we base them on two fundamental assumptions: 1/ that the photographer whose slide is being shown had a good reason for making the image and for choosing it for discussion; and 2/ that our purpose as instructors is to encourage students by helping them to make better photographs. Since using both sides of the brain – the dynamic, creative, feeling side and the rational, logical side – is as essential to photographing well as it is to living well generally, we place as much emphasis on emotional response to pictures as on logical analysis of them. Therefore, we are quick to praise both good seeing and good use of design and equipment to support that seeing.

For images that are less effective than they could be, we provide photographers with specific guidance for improving their use of design and/or photographic tools and techniques, usually prefacing our evaluation with such remarks as: "The overall impression of texture is beautiful, but you could have made it even lovelier by …" or "You have distributed the most important colours effectively throughout the picture space. Here's how you could have placed key areas of dark tone to support the colour pattern" or "You've used the sun as a powerful symbol of creativity in this image; by

overexposing a little, you would have made its rays brighter and stronger, further adding to the symbolic effect." The point or goal of our remarks is not good design or camera use per se, but rather the effective communication of information, ideas, or feelings that result from using them well together. Since students soon realize that we respect their efforts, they are receptive to the guidance and advice that we are able to provide, and they are not afraid to show photographs that are less than their best, but for which they want help. On those truly rare occasions when I blurt out, "This picture is a total disaster," the group invariably dissolves into laughter. They all seem to realize that major changes are required and are willing to accept criticism. (But, of course, it's never the sort of comment I make in the first evaluation session.)

A positive approach to image evaluation is much more than a technique for putting workshop participants in a receptive mood, however. As in every sphere of life, each of us is a creator, producing new creations, in this case expressive visual images. Many of our attempts to create fail, or succeed only to a limited degree, while others are truly successful. If you believe that the creative process (often, the creative struggle) itself is worthwhile, then you will respect the efforts of other photographers when you evaluate their work, and help them to improve their design and photographic skills – rather than merely criticizing what you regard as weaknesses – so their future creations will be stronger and better.

Most evaluations of your own images will probably take place at home, and you will be the evaluator. If you are like most photographers, you will be tougher on yourself than anybody else will ever be. That's good, if you can assess your work dispassionately. By that, I do not mean you should suspend your emotional responses, especially when a picture you've made really excites or pleases you. What I do mean is that you should not allow your personal insecurities – and we all have them – to be the gauge by which you measure the value of your images. Remember Alice, whom you met earlier; she had so little confidence in her personal creativity that she automatically assumed every picture she made was, at best, competent. In her view, non-creative people can make only non-creative photographs and, since she regarded herself as having no imagination, she felt incapable of improving her seeing and her photographs very much. Although Alice was a classic example of a self-fulfilling prophecy, the fact that she had enrolled in a workshop signalled to me that, deep down, she still had at least some hope. My role was to facilitate, to help her acknowledge and build on that hope by making some exciting images. When you are evaluating your photographs, be your own facilitator: acknowledge the weaknesses in your compositions, certainly, but also notice their strengths. Doing so will enable you to make future images with greater confidence. You can deal with those aspects of seeing and camera operation that you need to improve, because you know you are doing good work in other areas.

Another thing to be aware of in evaluating your own images is timing. After years and years of viewing my own new work, I still find that my initial response is likely to be my most negative. This is a very common experience among photographers. It's rather like the fish that got away. You had a good look at it, because with great effort that tested your skills and perseverance, you almost got it into the net – and then, suddenly, it was gone! The more you think about the fish, the bigger it gets. As a photographer you observe a scene through your camera's viewfinder and compose an image of it, often with an effort that tests your visual, conceptual, and technical skills; next, you press the shutter release, and then, in a sense, the picture "slips away" – for days, or weeks, or whenever you process the film, if you are using film. By now your photographic fish may have grown to colossal proportions in your mind, and when you first see the finished image, you are disappointed with it and discouraged with yourself.

With a digital camera you can see the result instantly and make an immediate decision to retain or delete the photograph. There are two real dangers here. 1/ Many photographers who use digital cameras tend to be careless or lazy about composition, thinking they will "work on" or "clean up" the image later. This means that they are giving less than their best effort to creating the original picture, and start off with an inferior product, so to speak. 2/ The instant or speedy rejection of an image does not allow time for sober second thought. Most of all, it eliminates the vital role a person's unconscious plays in creating images. Any good psychologist and many artists in all media will confirm that what any artist is dealing with unconsciously takes two to five years to bring into conscious awareness. I believe this firmly, because I have repeated evidence in my own images, which now span a period of nearly four decades. As a result, I have learned the benefit of delaying the final, tough edit of a shoot by one to six months, which at the very least removes me in time – and often in thought and feeling – from my original circumstances and mood. To put it another way, my snap decisions are usually less sound than my delayed or "considered" ones.

Let me describe a case in point. I remember a workshop during which a woman spent all one morning shooting on her own in a dead forest. She returned deeply excited, carrying three rolls of exposed film. Early the next morning I went into the darkroom to check the students' films hanging in the drying closet. When I came to those three films, I carefully took each one in turn and viewed it over a light box. The photographs were stunning – ghostly images that powerfully evoked skeletons and a world of the dead – achieved by means of overexposing the subject matter by two or more shutter speeds or lens openings. Later in the day, the photographer came to me in a state of dejection. "I'm not putting any slides in for evaluation today," she said. "I

ruined all the rolls I shot in the woods, because I forgot to change the film speed setting on my camera."

"Where are your slides?" I asked.

"Oh, I threw them all out," she replied and walked away. I raced to the waste bin and, picking through the debris, managed to locate most of the slides. A few had been scratched, but I blew the dust off the rest and spread them out on the light box. Then I selected 15 of the finest images and arranged them in a sequence. At the end of the evaluation session that afternoon, I said to the group, "Just before we break for dinner, I have 15 slides I'd like to project for you without making any comments." The response of the group was evident from the very first image, and by the time the last one faded from the screen, people were shouting, "Fabulous!" and "Incredible!" and demanding to know who had made the photographs. When I flicked on the room light, I glanced at the photographer (who appeared more than a little overcome) and asked permission to tell the whole story. What you should remember and practise when you evaluate your own work is this: don't evaluate the pictures you thought you made; evaluate the ones you actually made. After all, that's how you would evaluate the work of others.

By being willing to distance yourself from your own preconceptions and expectations, you will be receptive to learning from happy accidents. In fact, you will find that even some of your weaker compositions and poorer examples of lens and camera use can be instructive, especially when, instead of throwing them out immediately, you take a second or third look at them a few days or weeks later. Also, if you are photographing regularly, you will be growing visually – provided you are making personal judgements about how to arrange visual building blocks and not relying on "rules of composition" – and you will be making both conscious and unconscious advances in your understanding of design and how it influences expression, advances that can pop into your compositions without your being aware of them at first. By examining your images thoughtfully, you can accept, reject, or adapt new patterns emerging in your work and make the best of them part of your visual repertoire.

On the following pages of this chapter, you'll find several of my photographs and detailed comments about them. I'll tell you why I made each picture, why I composed it as I did, and in some cases add my personal emotional response to the final image. Sometimes my comments are largely technical; in other cases they refer more to the expressive or emotional qualities of the images. Both approaches are legitimate – in fact, essential – in evaluation. You should feel completely free to disagree with my analysis and evaluation of an image, but when you disagree, pretend that I'm sitting beside you. Think of yourself as the instructor responsible for providing me with constructive guidance on how to improve the quality of design in my images. In this way, you'll be helping yourself as well.

Wild cucumber blossoms and spider

When I poked my 100mm macro lens into a vine of wild cucumber blossoms, I did not expect a spider to leap out at me. But, visually, that's what happened. Because the spider was black and its surroundings mainly light (tonal contrast), because it was tiny and its habitat large by comparison (size contrast, or proportion), and because it was "an animal" in the middle of "a plant," I simply couldn't escape. When I set about photographing the spider in its natural setting, I relied on these distinctive features, and by making certain design decisions and using my camera and lens in certain ways, I was able to establish the spider's dominance in my picture as well.

First, I composed the picture. While making many minor shifts in camera position to distribute the flower stems and petals around the picture space, and checking the size of all the light sky spaces to ensure that none dominated the others (balance), I located the black spider within a light area for strong tonal contrast.

Next, with the lens set at its widest aperture, I focused on the spider. This rendered virtually all the plant material out of focus to some degree, and the resulting sharp-to-fuzzy contrast made the spider stand out even more distinctly.

Finally, I decided on exposure. Examining the entire picture space, I estimated that 80% to 90% of it was much brighter than middle tone, and that I would have to overexpose by about one-and-one-half shutter speeds ($1/20$ second rather than $1/60$ second, for example) to retain this brightness.

Perhaps what I like most about this image is the relationship between the spider and its surroundings. While the spider dominates visually, its size relative to the amount of space allocated to the setting expresses its dependence on its habitat. Observed from this perspective, the image is as documentary as it is evocative.

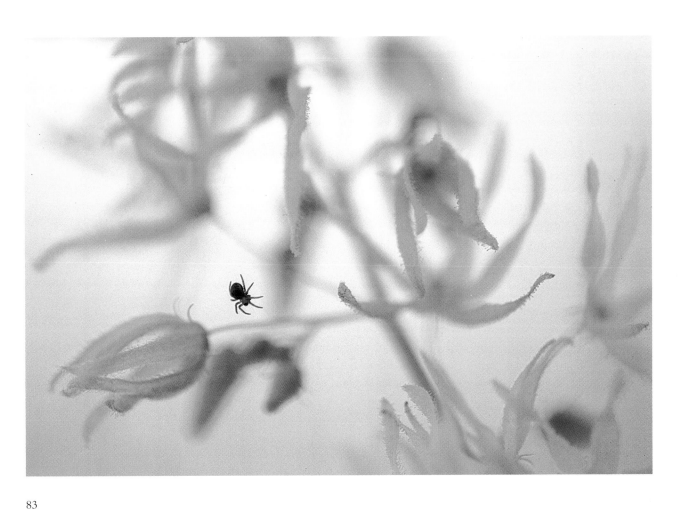

Field of daisies

A comparison between the smaller image and the larger one here shows the difference between a well-designed but very safe, traditional composition and one that provides more visual excitement and information. The smaller picture provides no suggestion of the strong wind that was blowing, but by making two simple changes – one in camera position, one in shutter speed – I was able to portray wind movement effectively.

From my first position, I moved just a few metres closer to the foreground daisies and tilted the lens downward in order to devote more space to the flowers. At the same time, I made a small change in the focal length of my zoom lens from 35mm to 28mm. Together these changes were sufficient to enlarge the daisies relative to the barn, creating a much greater sense of sweep across the hillside meadow. Then, instead of exposing at my original shutter speed of $1/125$ second, which was faster than the wind speed and "froze" the tossing flowers, I chose the slowest possible shutter speed – $1/30$ second (at the smallest lens opening, f/22). While this allowed for some blurring of the foreground daisies in very strong gusts, I felt more confident of success if I could slow down the shutter speed still more. Since I didn't have a neutral density filter with me, I added a polarizing filter to the front of my lens (not employing the polarizing effect, as it wasn't needed), to reduce the amount of light entering the lens. However, the resulting shutter speed of $1/15$ or $1/8$ second by itself would not have produced the sense of flowers tossing in the wind. My move closer to the daisies was just as important.

The two images – one quite static, the other dynamic – illustrate the changes that occur in our lives and surroundings almost from moment to moment. We are aware of this continuous process of change, if only subconsciously, because we are part of it. By arresting specific moments with a camera and lens, we are able to observe them longer and, perhaps, to appreciate and enjoy them even more.

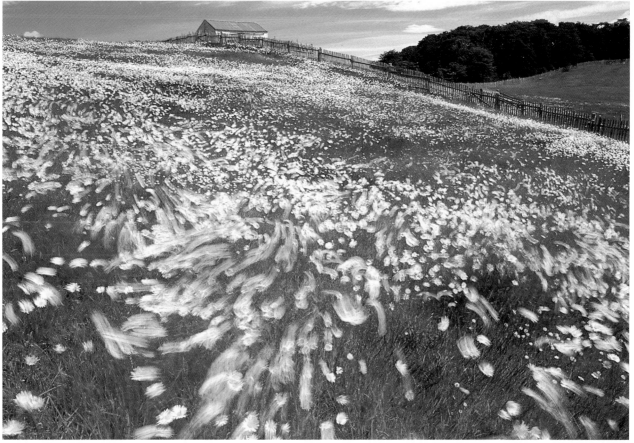

Abstract (interior of volcanic crater)

Because there is virtually nothing on which to pin a label, and almost no sense of scale, the appearance of this earthscape has a graphic purity. The building blocks of line, shape, and texture are powerfully evident, but perspective is virtually lacking. This abstract quality appeals to me tremendously. On the one hand, it allows me the freedom to roam, or creep, or soar visually over Earth's surface, the only limitations being the boundaries of my imagination. On the other hand, there is a lure about these patterns so basic for me that I long to be part of them, absorbed back into the ancient soils or the primeval sea.

It seems a shame, then, even for purposes of discussion, to identify the subject matter. However, this vast, curving, interior wall of an extinct volcano reminds me of familiar situations near my home, such as the local quarry and my long, gravelled driveway. In early and late winter, as melting snow begins to expose sand and pebbles, the sharply contrasting tones form striking textures. Water collecting in puddles contains the pig-mentation of surrounding soils and reflects the tones and colours of the sky. The crater, with its stark, austere weave of snow and volcanic ash offset slightly by the subtle texture and the muted colour of the water surface, is the quarry or the driveway written large. When I allow my eyes to see, the one scene evokes as great a sense of timelessness as the other and generates the same feelings.

In selecting part of the vast crater for a photograph, I had to make clear decisions about the design relationships between the visual building blocks. Because shapes dominate and frequently overwhelm textures, I reduced the visual weight of the largest dark areas by cropping every one with a picture edge and carefully balancing the resulting new shapes. In this way I used shapes to bring order not to the scene itself, but to my composition, surrounding and focusing attention on the textured area of ash and snow that sweeps down in a long curve from the upper left to meet the lake. The natural dynamic of the barren earthscape is enhanced by my camera position, which gives every line and edge in the picture an oblique orientation.

Perhaps I should add a very personal note. For reasons I cannot explain, a mainly black-and-white scene that contains a weakly saturated, secondary hue affects me at a visceral level. This emotional response to the dominance of tone over colour frequently influences my choice of subject matter.

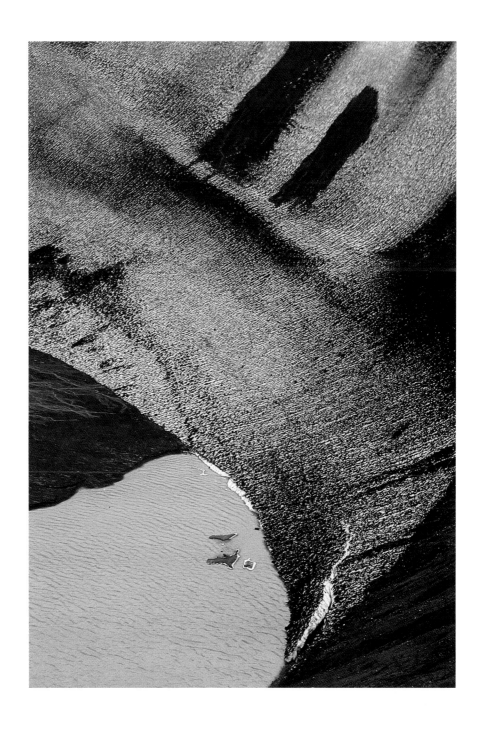

Woman shaving her husband

Although each of these photographs can stand on its own, the two are more compelling as a sequence.

The expressive content of both images depends strongly on the placement of certain lines (the arms of the man and woman) and shapes (their heads). In the first picture, both of the woman's arms lead to the man's head, where the visual strength of his arm pulls our eyes downward and back to the woman in an overall movement that causes us to see the couple as an integrated unit. In the second image, the same movement occurs, but not as strongly. Now only one of the woman's arms connects with the man and both of their heads are in relatively vertical positions, especially when compared with the strongly oblique orientations of the first photograph, which conveyed movement, action. Because of these design changes in the second image, we come to rest, as it were, on the woman's face – the point of maximum expression. As she looks directly at the camera, we can almost hear her saying, "There, that job is done. Now, what were you telling me?"

The objects surrounding the couple – the chair, stove, stovepipe, and wallpaper – provide information and contribute to our emotional response. We see and feel this elderly couple in an old-fashioned milieu still managing to cope with life's ordinary tasks – and we wonder what will happen to the survivor when one dies. However, the colour of the surrounding objects and the couple's clothing also had the potential for distracting attention from the people themselves, which is why I chose black-and-white film. By eliminating the competitive factor of colour and by paying careful attention to lines and shapes, I was able to keep the main focus on the relationship between the two people.

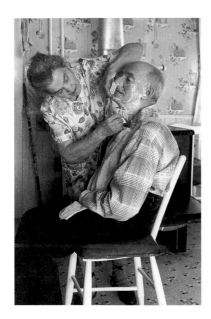

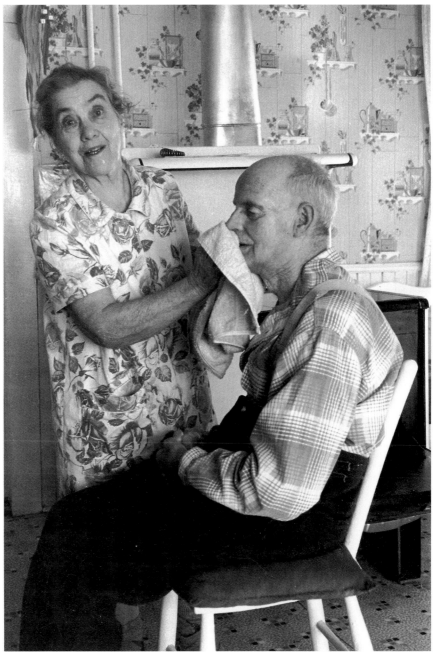

Tapestry (flower petals)

A few summers ago, a friend spent a morning cutting old blossoms off my rose bushes and other plants to use for pot-pourri. She put two large screens near a window in my barn and spread out the petals to dry. When I wandered in to see what she had done, I was struck by the beauty of the carpet of petals – saturated reds, delicate pinks, shades of cream and ivory, and tiny spots of black tone, all distributed more or less evenly. But, most of all, I was excited by the gentle dominance of blue delphinium petals, arranged in curving, almost-but-not-quite lines that moved my eye around and across the whole tapestry.

 As I viewed the petals through the camera lens and with my eyes alone, I realized how much the threads of blue needed the rest of the carpet for visual support. So, composing in either the vertical or horizontal format, I had to assess the outer dimensions of my pictures carefully. When I moved back some distance or used a wide-angle lens, the lines of blue remained visible, but their visual effect was diminished. When I moved in very close on a few petals, the impression of a tapestry disappeared, and the delphinium petals lost the appearance of lines or threads. Once I had established the range of distance in which I could work, I observed the rich, red petals, the pale, creamy ones, and the many spots of dark tone with the greatest care. More red, or light, or dark (all tiny, irregular shapes) on one edge of the picture than on the opposite one created a distracting imbalance. Did I move an occasional petal to overcome this problem? Yes, I did! However, every time I moved one, I seemed to create another problem. So I agonized over whether or not to drop a tiny pink or red petal into the extreme upper left corner in order to reduce the brightness of the creamy ones. In the end I decided against it, because in my judgement the light tone in that corner has the effect of lifting the eye ever so slightly, improving the curving angle of blue petals. What would you have done, and why?

Leaf silhouetted against curtain

During the course of a day spent at the house of an acquaintance, I passed this begonia plant many times, but never gave it a second glance. Then, a change in the direction of lighting created the effect that caught my eye. Light is constantly altering the appearance of visible things, including common objects in our homes.

The owner of the house was in a hurry to leave and had no interest at all in seeing the shadow pattern of a curtain imposed on the natural design of a leaf, so I was fortunate to be granted "two minutes, maximum!" to grab a camera, change the lens from wide-angle to medium telephoto, compose, and shoot. (Any thought of using a tripod had to be dismissed.) Now, years later, I cannot recall why we were in such a hurry that afternoon, what we did, or why it seemed so important, but I still have my photograph and my memories of that brief but beautiful moment.

Looking at the image now, I find the size and placement of the main leaf in the total space are good. The leaf is balanced, but not overwhelmed, by the more complex configuration of lines and shapes on the left edge. Perhaps what pleases me most, however, is that even under pressure, I was careful to create the same space or distance between the large leaf and the right edge of the picture, the top leaf and the top edge, and the right edge of the container and the left edge of the picture. The balancing of these seemingly minor spaces is not something an average viewer will notice – or needs to notice – because it's the sense of a pleasing arrangement that matters. Tempted though I was to eliminate the leaf sticking in at the bottom edge, I imagined my hostess's annoyance if I were to move anything, so I reduced its potential for distracting the eye by pressing it down enough to balance its width with that of the minor spaces I had created on the other edges.

As for the woman, I have never seen her again. But my wish for her – and my hope – is that one day she will become aware that the light streaming through the curtains onto her begonia and the television on which it sits is at least as interesting as the light coming from the television.

Hilly landscape

Sometimes riding a motorcycle offers definite advantages to a travelling photographer. This was one of those times. Coming over the brow of a hill on a highway that was both busy and lacking shoulders, I was able to pull off, park the bike on a narrow strip of grass, and then take time to photograph this strikingly simple scene.

The picture contains only two hues and two tones (black and a light middle tone). The dominant hue – the brown of the grass – indicates late summer or autumn. The tones provide the contrast, creating a long, powerful oblique line that divides the picture space into two balancing triangles, and a shorter shape and line (the green tree and its shadow) that complement the movement of the longer line, while at the same time functioning as a point of dominance or visual resting place. (The spot for a picnic would clearly be in the shade of the tree.)

While the tone of the large brown field areas is remarkably uniform, there are, in fact, incredibly subtle variations of brightness within both triangles. In the upper triangle these variations form barely perceptible oblique lines or shapes that move up or down at right angles to the main oblique line of bushes, preventing monotony, the wearisome sameness resulting from a lack of tonal contrast or variation.

I could not have made this particular composition without using a zoom lens (in this case, my 100-300mm set at about 250mm). If I had been using a lens of fixed focal length (let's say, 135mm or 200mm), I would have had to approach the tree and shrubs more closely, losing altitude in the process. While this move would have resulted in the tree being elevated to a position on the same oblique as the bushes, thus becoming the point at the bottom of an exclamation mark (a visually dramatic effect), it would have forced me to include some very competitive blue sky. If I had tilted my camera down to avoid the sky, I would have enlarged the lower triangle at the expense of the upper one, throwing the composition off balance. If I were a painter, of course, I could have had any arrangement I wanted. In many circumstances photographers must deal with specific physical realities that artists who work in other two-dimensional media can choose to ignore. This was one of those circumstances.

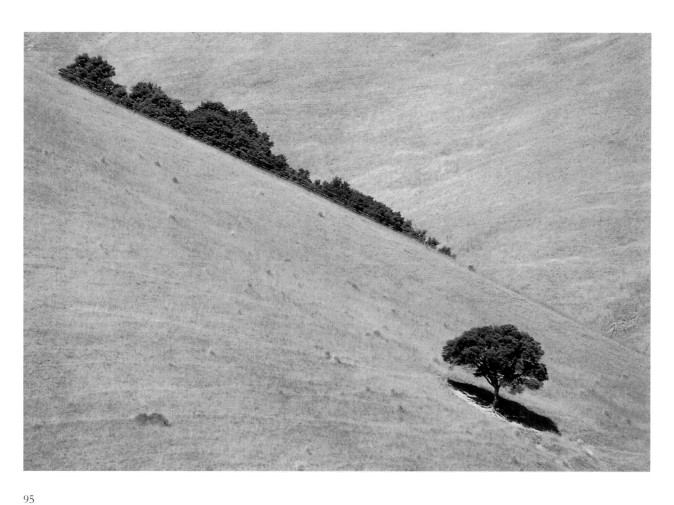

Woman

Several years ago I hitched a ride in a pick-up truck through the dry bushveld of northern Botswana. Because the driver, a government employee who was making an annual trip to remote villages, had the seat beside him stacked with envelopes, I rode in the open back. It was a great way to see the country and, between bumps and jolts, to photograph it. Late one afternoon as we came around a bend in the dusty track, we encountered a small group of women returning home after a day spent hacking out a garden plot in the hard soil. Usually such unexpected meetings with strangers were filled with chatter and laughter, but these women were so exhausted they asked only for a drink of water from the barrel beside me. They were quite oblivious to my camera.

Of the photographs that I made from the back of the truck, this is my favourite. When I analyse it, I can identify several things I did well – filling the space without crowding the woman, pressing the shutter release at the moment when her eyes were downcast and virtually all the lines and edges of her clothes and body were either curving or oblique (collectively evoking a sense of her fatigue), choosing a depth of field that kept the woman in focus but not the background, and exposing perfectly for her skin. I can also see things that I wanted to control but couldn't at the time, particularly the harsh illumination of the white sheet the woman was wearing as a carry-all. However, the same sidelighting illuminated her patterned kerchief drawing some attention away from the bright sheet and to her face.

The analysis of a pictorial design is very useful in understanding why a composition, including this one, is successful or not, but it doesn't explain everything. In this image, the qualities of the whole clearly transcend the attributes of its component parts. No amount of analysing the arrangement of the picture's building blocks can tell me why I sense a sadness in this woman, or why I feel so drawn to her at a moment when she has retreated into her private self.

I believe photographers should let their emotions go when experiencing images – both their own images and those of others. If a picture delights you, enjoy it. If it saddens you, allow yourself to feel the sadness. But if a photograph you have made sends contradictory messages, or shows no clear commitment to a point of view, or fails to deliver the intended information, then analyse the design so you can convey your feelings more effectively next time.

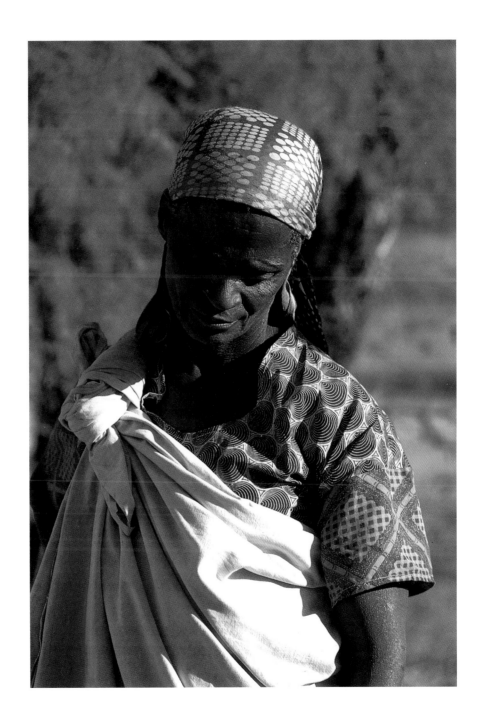

Mountain scene with boulder

Composing this photograph, which I made one Christmas in Argentina, was difficult for a couple of reasons. First, because the wind was blowing at hurricane force, I couldn't stand up. Neither could my tripod, except when I held it firmly by one leg at its minimum height. Second, numerous shapes competed for attention with the huge, round, black boulder, which I wanted to establish clearly as the centre of interest.

By slithering around on the rocks, I was able to position the boulder in a dip between two triangles – the mountain to the left and the sloping foreground rock to the right. This isolated it against white clouds, strongly defining it as a solid black orb that dominates the picture space.

However, I still had work left to do. Notice that, from bottom to top, the picture is composed of four alternating bands of darker and lighter tone. This rhythmic arrangement of shapes, along with the dominance of the circle, gives the composition order. Nevertheless this naturally good organization could be sustained only if I found some way to relate the sky and upper cloud area to the base, with its internal triangles. The only prospect seemed to be in the constantly changing edge of the upper cloud. So I waited until the cloud, billowing and sweeping across the sky, retracted part of its edge to form an impression of triangularity that, inversely, replicated the dip in the base, where the large rock stood. Then, with all my fingers and toes firmly crossed, I delayed pressing the shutter release until the distance between the right edge of the picture and the high point of the triangle in the cloud was equal to the distance between the left edge and the low point of the dip at the bottom of the picture. This balancing of spaces (or of the two points, if you prefer) not only helps to maintain the order already established in the composition, but also adds visual tension. Psychologically, this tension prevents the boulder from rolling down the mountain.

Normally, I don't spend Christmas photographing boulders high in the Andes, but late that night when I crawled into my sleeping bag, I realized Santa had not passed me by. My gift had been the wind that forced me to crawl around on my stomach. It had enabled me to see the tiny rocks that elevated the boulder and presented me with a complete and powerful shape.

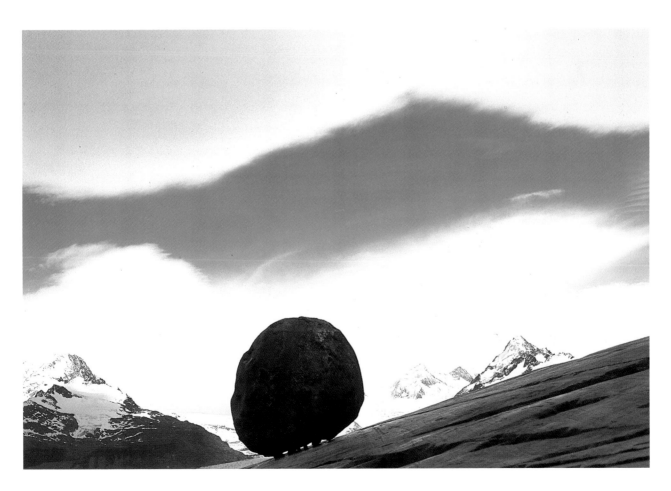

Old building with signs of life

One morning on New Brunswick's Grand Manan Island, a friend and I took our cameras and tripods along to some of the old wood buildings where fishermen smoke herring. Both of us were attracted by the simple geometry of the structures, especially the shapes formed by contrasts between the red doors and panels, the rows of weathered grey shingles, and the black interiors. After we had photographed for an hour or so on the shaded side of the smoke houses, sunlight began to catch open doors that swung out from the buildings, creating new lines and shapes and emphasizing certain existing ones. About this time my friend decided to climb up to an interior beam for a view from one of the open windows. When I saw his hands grasping the sill, I shouted, "Hold it!" and quickly moved my tripod and camera into position. However, it took me a few moments to determine my overall composition and check the precise arrangement of shapes. Despite his superb physical condition, my friend soon tired of hanging by his hands and was screaming for me to hurry up.

The image I made lacks true symmetry, but on the whole the geometric shapes are so formally balanced that the picture has tremendous order and stability. My friend's hands and the short vertical band of sunlight, which are of equal visual weight, balance each other asymmetrically, and the tension between them induces an oblique eye movement that brings some dynamic to the composition.

Half an hour later, when the sun was illuminating the whole side of the building, the relationship between shapes had altered, and the texture of the old shingles was emphasized. My friend, who was more excited by the new lighting conditions than I was and noticed that I was taking a break, yelled, "Okay, it's your turn! Hang from the window – outside will be fine!"

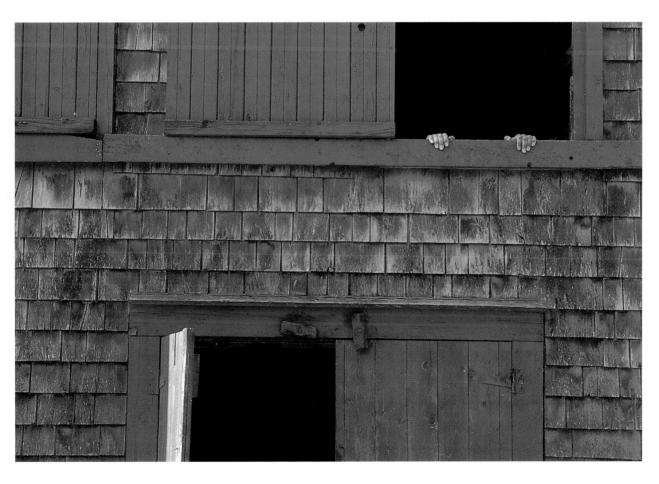

Railway tracks at sunrise

This photograph of railway tracks in downtown Toronto reflecting the golden light of sunrise illustrates strongly that in situations containing only one hue, we rely entirely on tonal contrasts to see lines and shapes and other visual building blocks.

Because the tracks are so light and the spaces between them so dark, the golden lines have enormous visual impact. Most of them lead strongly from the foreground in the bottom of the picture space to the point in the background where they converge and disappear, or to some people they lead and diverge from the background to the foreground. In either case, those lines that curve or cut across the others have the effect of varying and slowing down the main movement. This complexity adds interest to the design without impairing its overall direction.

I examined an alternative composition – tilting the camera up to include a sliver of yellow sky – but rejected it. The horizontal position of even a thin rectangle of sky competed with the more or less vertical thrust of the lines. Furthermore, because of buildings and signs at the horizon, the bottom edge of the sky rectangle was uneven and distracting.

For me the photograph has a compelling design, interesting from that point alone. But what it does not reveal also interests me. Because there is no horizon, no visual stopping point in the form of sky area, the lines disappearing into the blackness lure me into an unknown place. I can only imagine what that place may be.

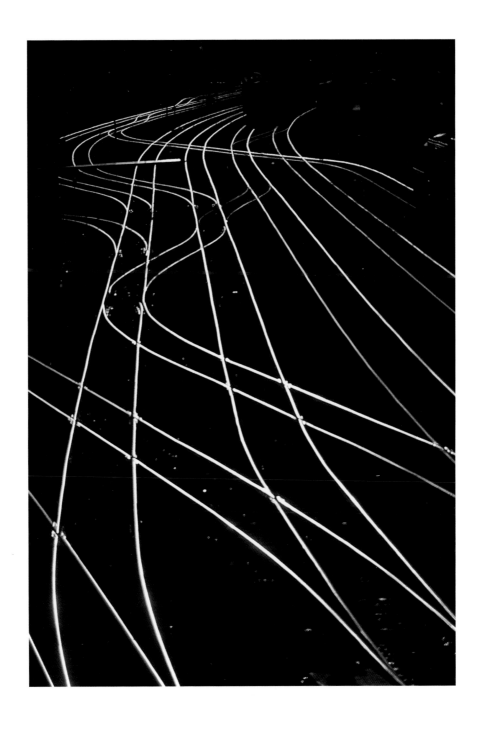

Abstract (oil and water)

One summer afternoon I was sitting on a deck recently stained with creosote. A heavy shower forced me inside for half an hour, but when I returned I immediately became fascinated by the constantly changing patterns of oily water on the deck boards. Back inside I went again, this time for my tripod, camera, and 100mm macro lens. For the next few hours I sat on the bench, tripod between my legs and lens aimed straight down at the water patterns. By the time I had exposed about three rolls of film, most of the water had evaporated in the wind and sun. Since a second shower did not seem forthcoming, I sprayed the deck with water from a garden hose and resumed shooting. This is one of the many different images I made that day.

Unlike many people, I never deliberately look for and only occasionally observe representational or recognizable shapes in non-representational materials. For example, you'll never hear me exclaim, "Oh, see the face in that pile of rocks!" or "Don't those clouds look like a flock of sheep!" There's nothing wrong with pinning new labels on rocks or clouds, except that it tends to bring a halt to examining things as they are, and especially to observing their natural designs. To be frank, it's not the "sheepness" of a flock of clouds that excites me, but the way the puffy whiteness at the top of each cloud gradually deepens to grey at the bottom. I love slow, gradual tonal transitions. I am moved by the weight and solidity of huge boulders far more than anything the rocks resemble. (The answers are buried down deep, where I feel.) So the reason I spent an entire afternoon observing and photographing lines, shapes, and textures in oily water is because I loved the lines, shapes, and textures. I was excited by the movement, the constant change, the sense of watching the universe unfold.

In a superficial sense, this doesn't tell you much about the picture on the facing page, but perhaps it will explain something of what motivates a lot of my picture-making and encourage you to think about what motivates yours. What we see and photograph are surfaces. Often compelling in their own right, surfaces may also be powerful expressions of what's underneath. Observing visual building blocks as raw material being formed into structures by dominance, balance, proportion, and rhythm helps us to get under surfaces – especially our own.

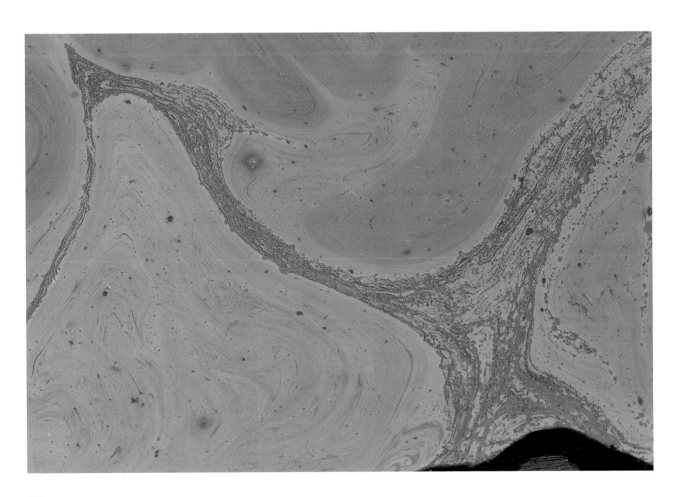

Assignments

Towards the end of most workshops, my teaching partner and I give each participant a personal photographic assignment – an object, situation, feeling, or idea – to work on that day. Everybody is expected, above all else, to explore, and then from the photographs they make, to select between 10 and 25 images for presentation to the entire group as a sequence, story, or essay.

As we read out the list of assigned topics, the room resonates with laughter one moment and with groans of simulated agony the next. However, everybody accepts his or her assignment as being serious business, and in a matter of moments the group has scattered.

My partner and I take a break for the rest of the morning, perhaps chuckling over coffee at the horror a particular student expressed when handed his or her assigned subject, or sharing the delight of another who commented enthusiastically, "Oh, I've always wanted to try something like this, but never thought I could do it!" We choose every assignment with the specific photographer in mind. Sometimes we want a person to zero in on a weakness, perhaps exposure, and assign a practical exercise – making expressive images that depend on drastic overexposure or underexposure. Sometimes we want to encourage somebody to develop a latent strength, perhaps a natural sensitivity to rhythm, and suggest making a collection of images that have no centre of interest but whose expressive force emanates from the predictable recurrence of lines or shapes. Or we'll challenge a photographer who specializes in wildflowers and insects to switch gears by assigning a morning photographing shoppers at the local convenience store. Other times we try to give a photographer one last creative shove:

photographing "outer space" or "bedsheets as landscapes" ought to do it. And other times still we want a person simply to have fun using his or her imagination, assigning something nonsensical, such as "how bath towels make love."

The second half of the assignment begins when everybody gathers around large light boards or computer monitors to sort, edit, and arrange images for presentation later in the day. The noise level rises as photographers scrutinize the results of their efforts and, if invited, the images others have made. This interaction can be very useful, especially when it elicits spontaneous reactions, but it's not for everybody. Some photographers prefer to work alone and to wait for the actual presentation to hear the response of other photographers and, often, a few guests from the local community. In either case, the selection process makes everybody aware that the two parts of the assignment have quite different purposes. In the first part, a photographer's energy is engaged primarily in relating to the subject matter, especially if it is mainly a vehicle for conveying an idea or feeling. In the second part, one's focus switches to the people who will be viewing the selected images. The overall goal is to engage viewers visually and emotionally while being faithful to the experience of working with the subject matter. The chances are good that the more involved the photographer became with his or her subject matter, the easier it will be to arrange resulting images around a coherent theme. In fact, in many cases the theme emerges during the shooting process, and the photographer's challenge in the selection process is to choose the images and sequence that express it most effectively.

The two hours the group spends viewing the various sequences of projected photographs is a time for stimulation, enjoyment, and appreciation. My partner and I keep analysis to a bare minimum, or refrain from it altogether, because the workshop participants provide one another with the really important feedback – emotional response. Besides, by this time in the workshop, everybody is quite capable of making reasonably informed judgements about when and how the design of an image or a sequence of images supports, enhances, or weakens the subject matter's intrinsic design or symbolic content. What students hope for – and receive – from one another are new ideas and new visual approaches.

Many workshop participants use personal assignments as a way of continuing their visual and emotional growth after they have returned to their homes. Those who set time aside to photograph on a regular basis are usually the most successful. A stockbroker from a major city decided to make a break from his professional and personal lives by spending time every Sunday photographing back alleys. Two friends from another city, who for years had shared Wednesday lunches and afternoons, spent their time together for six months giving each other weekly assignments and then showing each other the results. One might be exploring distorted reflections in a sheet of

aluminum foil while the other was engrossed in the patterns formed by the veins of a leaf. The following week they'd show each other a selection of the previous week's slides, trade new assignments, and set to work again. Two other photographers came up with a variation of this shared experience. Each thought up ten assignments for the other, wrote down the topics on separate pieces of paper, and dropped them into a small bottle. Then they traded bottles. Once a week each photographer drew an assignment from his bottle and set to work.

The value of having somebody else assign a topic, theme, or particular subject matter for you to explore and photograph is at least two-fold. First, a friend may be less likely to indulge your preconceptions about what will make a useful project, thus forcing you into territory you might never explore on your own initiative. Second, a good friend, whether a photographer or not, has a personal interest in your accomplishments and can usually be quite open and honest in expressing both feelings and thoughts about what you've done.

However, most photographers will have to pick their own assignments. There's no reason not to try things you've long wanted to try but simply haven't got around to. Initially at least, it's wise to steer clear of any subject matter, situation, or techniques that are merely variations of what you handle well. Challenge yourself, not by substituting one glass skyscraper for another, but perhaps by returning to a familiar building with a lens you have always considered inappropriate for architectural work. And give yourself some assignments that have time constraints – for instance, one hour to make 36 different but good compositions of a favourite tree, or 15 minutes to make 15 photographs of your husband reading a newspaper. These exercises will help you to be decisive, which is especially important when you're photographing a rapidly changing situation, such as a parade or a figure-skating competition, or when autumn leaves are floating towards the brink of a waterfall. And make sure to assign yourself some subject matter to which you have a natural aversion (say the mess of your son's bedroom) or a situation in which you feel a certain unease about making pictures (perhaps the local pool hall). One of the best possible reasons for photographing anything is to overcome your aversion to or fear of it – photography, after all, is as much about relating to subject matter as it is about learning to use new tools and techniques. And it's the relatedness to abstract configurations of tone and colour, to back alleys, and to people you might not normally meet that can give you a greater sense of personal accomplishment and well-being.

Often I'm engaged in several assignments more or less simultaneously. For example, my photographing of Kevin (see pages 123 to 127) was spread over several months. At the same time, I was shooting images of a paperweight (see pages 147 to 149). The respective subject matter could hardly have been more dissimilar, and for the

most part I used different lenses and employed different natural lighting for the two assignments. And yet the feeling of excitement generated by each project carried over into the other, producing an emotional double impact. Because my motivation level was so high, I continued both projects much longer than I might otherwise have done and learned more in the process.

People sometimes ask, "But what will you ever do with all the pictures you make?" Quite frankly one might just as reasonably ask, "What do you do with all the flowers you grow?" or, "Why do you spend time playing tennis or the piano?" Although as a professional photographer I use my images in a variety of ways to earn a living, and as an amateur photographer I use them in other ways for personal pleasure and satisfaction, I rarely have a purpose in mind when I make a photograph – other than making the photograph. In short, I think of every picture as being its own reward, and the experience of making it as being worthwhile in its own right. The real value of a photograph, like the real value of a piece of music, accrues first of all to the creator. By showing the photograph or playing the music, the creator shares the experience – and its value – with others, whose seeing or hearing is also an experience that requires no further justification.

Think of assignments in this same light. We should certainly undertake them for their instructional value or for the purpose of sharing the resulting pictures with others through photo albums, audio-visual presentations, and exhibitions. But ultimately both an assignment and its resulting images have intrinsic value that requires no utilitarian explanation and, in itself, is more than sufficient reason for engaging in the project.

In the following pages are some photographs from a few of the assignments I've given myself. I shot four of the assignments at home, two at the houses of friends, and the other six at places I was visiting. Several of the assignments were rich emotional experiences, and others simply helped me to hone particular techniques or aspects of design. Some projects were relatively brief exercises, others spanned several weeks, and one required a year of intermittent shooting because the appearance of the subject matter – the field behind my house – was constantly changing with the seasons. When a minimum number of exposures or a maximum time limit was necessary or helped to make an assignment really useful, I've indicated this in brackets as part of the assignment's title.

For the purposes of discussion I've grouped the assignments into three general categories – people, nature, and manufactured objects. However, as you'll see, the categories often overlap. Natural things, for example, are present in virtually every assignment, if not in every picture, and manufactured objects often appear in images of people.

Since it's impossible to make a photograph without including existing shapes or creating new ones and the same is virtually true of lines and edges, I hope the ways I've used the visual building blocks in my pictures will encourage you to consider how you are using them in yours. Treat my images as examples, or guides, if you like, but don't feel constrained by them or regard even a repeated usage as a formula for success. Although certain arrangements of the building blocks always seem to produce visual order and others to engender a sense of dynamic, these qualities will be expressive only if they relate well to your subject matter and what you want to convey about it. And through your thoughtful but personal use of visual design, you will be expressing your feelings as well.

People

Nearly everybody makes pictures of people – mostly people we know and love. Chances are that we interact with them frequently, perhaps every day at home or on weekends and holidays. Others we see less often, perhaps only at family gatherings or certain community events. Because we know them so well – and they know us – we can easily grab a few shots of Lisa bouncing on her trampoline any afternoon, or ask Dad to peer out from behind the wheel of his new truck.

Sometimes, however, our familiarity is a hindrance to making good photographs. Brian is forever sticking out his tongue, and Mary insists on posing formally just like her great-aunt Sarah. Frankly, there are days when we wish our friends and relatives would behave in a more co-operative manner – like trees, for example. Nevertheless, many of these pictures – good and bad – make it into our personal photo albums, bringing us repeated pleasure and, collectively, forming something of an historical legacy.

Perhaps the only people we'll ever photograph are people we know. Or maybe we'll ask to make a picture or two of the wonderful couple who helped us out when our car broke down on a remote country road or, getting more daring, to "take a snap" of the attractive lifeguard we spotted at the beach. Gradually we begin to feel easier about photographing strangers, but then one day we notice a very old man resting himself and his bag of groceries against a lamp-post. We want so much to photograph him, but because we are afraid to raise our camera or to ask him for his photograph, we walk on by.

I remember a time when the very idea of photographing a stranger in a public place filled me with dread. In my memory lives a whole host of people and situations I was afraid to approach – a personal album of pictures I never made. I've come to realize that to a greater or lesser degree many photographers suffer from the same inhibitions. In most cases, we have a pretty good idea why we react this way, but knowing the reasons for the problem doesn't solve it. Some form of practical but creative action

is required. By setting yourself a series of assignments – photographing a relative or friend as a project, then moving on to others as your confidence grows – you are taking that action.

Begin by photographing somebody you know well and feel comfortable with – your grandmother, a favourite uncle, a good friend, or a fellow photographer. In workshops I sometimes ask a participant to photograph a spouse or partner, beginning with "habitat shots" (the partner walking down a path, for example) and moving on to semi-close-ups and close-ups. Or I'll provide two photographers with a prop, perhaps my motorcycle, and ask them to take turns modelling for and photographing each other around and on the machine. One photographer, an older man, completed his assignment of photographing his wife by placing his camera on a tripod, setting the exposure-delay switch, and then joining his wife in the composition.

Next, try a more public situation, but one where at least some of the people know you and won't be surprised to see you making pictures. A family picnic is always a good place to begin, but a local service station where you know the owner and a few of the customers is even better. Or make pictures of a community parade, a sports event at your neighbourhood school, or construction workers building some senior-citizens' apartments for your church or synagogue. In all these situations you'll have excellent opportunities to get some good pictures, and you'll find any inhibitions or fear about photographing people draining away. Assignments like these that develop both your confidence and your skills are invaluable preparation for making pictures in unfamiliar surroundings and with people you're meeting for the first time or may never meet again. An elderly gentleman resting on a park bench in Seoul or Nairobi may not be your grandfather, but he's undoubtedly somebody's grandfather, and if you've photographed your own grandfather back home, you'll probably get along with him just fine. Your assignment experiences will give you confidence even when you don't speak the same language. Don't be surprised to find yourself communicating by means of a smile, a nod or shake of your head, and simple hand movements. After a while your body language will be as effective in communicating your intentions as your speech.

Although there will always be some situations that will make you uneasy or uncomfortable, you'll know you've graduated as a photographer of people when you can approach a group of strangers with a smile and a wave of your camera, make some pictures, and then engage them in conversation or depart with a simple "Thank you." You'll know because you no longer automatically try to sneak pictures by using a long lens. Most of all, you'll know because you consistently consider the people you're photographing, not yourself.

Some aspects of photographing people are so fundamental that you should consider them even before you begin. What follows is a summary of the ideas and guidelines that I consider most important.

First, be considerate of your subjects both as persons and as models. Even when you have a more universal theme in mind – happiness, loneliness, camaraderie, the physical and emotional effects of famine – remember that the people are the expressive content. What you provide is the approach, treatment, and picture design that harmonize with the content and make it clear.

Second, except for extreme close-ups of a face, hands, or other parts of the body, consider people in relation to their surroundings. A room, building, street, garden, expanse of water and sky, or a collection of tools, boots, or porcelain dolls will provide hard information and evoke ideas and feelings about a person's character and personality. Even when the surroundings are unrecognizable or you have deliberately thrown them out of focus, the space around a person influences our impression of the person.

Third, pay attention to the visual effects produced by a/ the quality of light (soft on an overcast day or in the shade, harsh in sunlight or from a flash aimed directly at your model); b/ the direction of lighting (front, side, or backlighting, or a mixture of these); and c/ the colour of light.

Fourth, for most situations, keep your choice of equipment as simple as your needs. One or two cameras and lenses are better than a camera-bag arsenal. A tripod is extremely useful when someone is posing for you. A flash and/or reflector may be useful, but if you can work easily without them and they add weight and bother, eliminate them.

Whether you are documenting a human situation, telling a story using simple, bold design for graphic presentation of the human form, making close-up portraits, or creating romantic interpretations, remember that what matters most is to treat people as subjects, not as objects. If you do that, you will strengthen their sense of self, enjoy their company, and very likely make some fine images.

Portrait of a friend at home (time: one hour)

Jean Isaacs is my former secretary and a friend of many years. When we were working together, I saw her nearly every day but as is so often the case with people one knows well, I never asked Jean if I might photograph her – although the idea was always somewhere in the back of my mind. Then one day I asked if she would like to be "an assignment" for a couple of the participants in a workshop. Jean, who is an amateur photographer herself, agreed readily to being on the other end of the lens and enjoyed the experience.

When I saw the photographs my students had made (the two sets being quite different from each other), I decided not to delay photographing Jean myself. Since Jean now has difficulty in walking more than a short distance and because she is very much at home in her log house, we used it as the location. I asked Jean to pose in characteristic situations or to do things she is accustomed to doing, such as reading in her living room. The resulting images, made during a one-hour shooting session, are part of a quiet document of Jean at home.

Even when I was shooting indoors, which was most of the time, I relied mainly on the natural light coming through windows. The reflected hues of walls and other materials gave a pleasing warmth to Jean's skin, especially in close-up images, that surpassed the colour quality of the few images made with direct or bounce flash. When tonal contrasts were strong, I moved back in order to include more of Jean's surroundings and to reduce her size relative to the overall picture area. For all the interior images, many made at speeds as slow as $1/8$ second, I overexposed by one shutter speed or lens opening to preserve light tones. If there were brilliant highlights, I either eliminated them from my compositions or treated them as accents.

When I visit Jean I usually find her reading in her living room, so it seemed a natural place to begin photographing her. Next we moved to her new bedroom and bathroom. Since we know each other so well, both of us were completely relaxed and Jean began hamming it up. The picture of her peering from behind the shower curtain is a pleasant example. "Do I have to take my clothes off?" she asked. "Just uncover your face," I replied.

As I was leaving, Jean was standing on her front deck looking towards the woods that surround her log-cabin home. Sunlight outlined her body and highlighted her beautiful white hair. It also transformed the deck railing into a strong line that leads to Jean, emphasizing her even more. I like the sense of her being alone again that this image conveys.

People in motion

The following two photographs are from a commercial assignment. Since the pictures were to be reproduced in black and white and to show people in action or motion, I selected two monochrome films – a slow-speed film for blurring or panning and a high-speed film for arresting or "freezing" action. Both of the pictures you see here were made with the slow-speed film.

Using a shutter speed of approximately $^1/_8$ second, I caught the dancers at a moment of peak action. This produced some blurring of their bodies, conveying movement, but still provided enough definition for them to be recognized as dancers, especially against the black background that I had selected.

I made the calf-roping photograph at a small-town rodeo, where the action is always as exciting as at a big-city event and manoeuvring into a good position is much easier. With the camera set at a shutter speed of $^1/_{15}$ second, I aimed my camera at the calf as it burst out of the gate, following it and the cowboy in the viewfinder as they streaked down the length of the corral. Since this was a competition, the action was repeated several times – with a different calf and cowboy each time – so I had plenty of practice not only in following the action but also in determining a good time to press the shutter release. Because my camera and lens were moving at the speed necessary for keeping the calf and cowboy in the viewfinder, everything else appearing in the picture space was effectively blurred. This technique, called "panning," is like swinging a baseball bat – only you hit the shutter release at some point in the swing, instead of a baseball.

Although both images document a human activity, movement or action is the real subject matter, an impression that I was able to convey by means of camera techniques and visual design. Neither image reveals the character or personality of the people involved, but both suggest human vitality and creativity.

The blurring of the figures in this image helps to convey a sense of movement, but the feeling of dynamic activity is also evoked by all the oblique lines and shapes. There are no restful horizontals or stable verticals in the body positions of the two dancers to compete with the expressive power of the obliques. In the uncropped original some of the floor showed, which diminished the feeling of flight. This is one of the rare occasions when I chose to use less than the full picture format.

In this case it is the blurred surroundings that imply that the lens was tracking a moving object – even though the cowboy and calf are, for the most part, sharp in the picture. The stretching of stationary objects (shapes) into long continuous horizontal lines adds to the impression of motion.

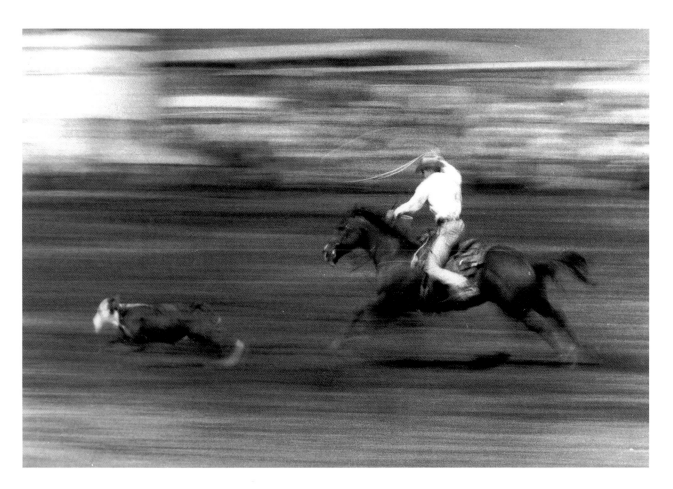

Portrait of a stranger (time available: ten minutes)

At my workshops in Namaqualand, we sometimes spend a day or two photographing people in the mountain villages where my teaching partner, Colla Swart, seems to know everybody. One day she took our group to Rooifontein, where this elderly woman asked to look into Colla's eyes ("I want to see your soul," she said) before pronouncing that she would be "honoured" to have us photograph her. My favourite portrait is of her hands holding some oranges.

The situation was instructive in several ways. First of all, students who were uneasy about their status as visitors and concerned about "exploiting" the villagers soon realized that Colla loved and respected these people and that she made pictures only after she had obtained their permission and co-operation. By putting people ahead of pictures, she put everybody at ease, a lesson that is relevant everywhere.

Another lesson I learned in Rooifontein is that "it's not over 'til it's over." In other words, stay alert to picture opportunities that occur when you and the people you are photographing are preparing to part and everybody is likely to be relaxed. That's when I made this photograph. Making a final quick shot or two is not inappropriate behaviour when you have established good rapport, especially if you can honestly say, "Thank you for that last picture. You looked just great."

The old woman died a couple of years later. Not even she knew how old she was, which is to be very old indeed. I am very grateful for the few minutes our lives intersected, and for her kindness in letting me photograph her hands. The natural ease with which she cupped and held the oranges – the design of her hands – suggests the whole person. Sometimes the most evocative portraits do not show a person's face. Making expressive portraits by focusing on hands or other parts of the body is an excellent assignment for anybody who enjoys photographing people.

Good pictures of people are made by photographers who recognize the expressive potential in the shape of a person's body or face and in the shapes and lines formed by arms, hands, and clothes. Here the cupping of an old woman's hands conveys as much about the woman as the tilt of her head or the line of a smile ever could.

Extended portrait study

Kevin Laskey rides a Harley-Davidson, and so do I. Both of us have a lot of biker friends. For some time I'd wanted to make photographs of a man, about Kevin s age, who looked comfortable and easy with his machine. Through a couple of friends I was introduced to Kevin. We met, talked about what I had in mind, and several weeks later got together for our first shoot.

To be successful, a model has to represent more than himself. He or she has to project a certain universal quality or appeal. Kevin's good looks, well-proportioned and well-developed physique, and his unassuming masculinity all suggested studies of male sexuality and body sculpture.

Over the course of two months, I spent several afternoons photographing Kevin outdoors in the autumn light. Before each shoot, we'd review pictures from the previous session and discuss why certain images were more successful than others. I'd explain the impact of design – how and why the position of an arm or leg, the tilt of his head, or the shape of his body in relation to the background influenced my responses. Kevin contributed his ideas too, often suggesting situations or clothing that appealed to him or in which he felt particularly comfortable. After our very first session, we were feeling relaxed with each other and from then on worked easily as a team.

Both Kevin and I preferred a camera with rapid automatic film advance, because it allowed him to hold a pose briefly or to change positions freely while I recorded his movements. I also used a tripod most of the time. It made the careful planning of compositions easier and gave Kevin the opportunity to look through the viewfinder when I wanted to demonstrate a possible pose or movement.

The bonus for working together on this project, in fact the best reward of all, is that Kevin and I have become good friends, sharing our common biking interests over a round of beer or a bottle of wine, enjoying a meal together with his parents, discussing everything from our likes and dislikes in music to the ups and downs of human relationships.

In this portrait of Kevin relaxing on my deck, the open country surroundings give visual support to his warm, open personality. In particular, the brightness of the water, which harmonizes with the tones and colours of the deck, and his denims, draws our eye up through his body to his face.

In order to capture Kevin's sombre, almost worried expression, I quickly created a simple, bold arrangement of shapes – the large triangle of his body balanced by a smaller, out-of-focus triangle on either side. This design puts all the emphasis on Kevin. As in the picture above, the tone of his clothing reinforces his mood.

Kevin is a serious biker, and he is deeply attached to his Harley: the machine expresses something fundamental about who Kevin is and who he wants to be. For this image I used an on-camera flash to highlight the chrome and headlight and to strengthen the rendition of colours, especially the red. The powerful lines and shapes of the motorcycle are replicated by Kevin's head, arms, and leg.

The wedding of man and machine: in this photograph Kevin, like the motorcycle, is symbolic. He represents all bikers. The visual unity of Kevin and the bike – especially the parallel between the strong, oblique line of shiny metal and Kevin's long leathered leg and boot – forms a new, more powerful symbol and, for some, arouses primal feelings.

In overall design this composition is similar to the lower image on page 124, but there are important differences in other respects. Kevin's downcast eyes and the position of his hands contribute visually to his pensive, reflective mood, and the overhead lighting creates strong shadows on his cheeks that give his face a somewhat sculptural appearance and make him seem older and wiser than in the earlier image.

Kevin's powerful body is, in a sense, a living sculpture, and here I used sidelighting and bold graphic design to emphasize the symmetry and massive shapes in his physique. As a man who is comfortable with sexuality in general and his own in particular, Kevin understood and felt easy about the possibility of his body being regarded as a sexual symbol and posed without embarrassment – a rare trait in someone not used to modelling.

Natural things

You can get an idea for a nature photography assignment anywhere, any time – as I did the day that I took a cup of tea with me and sat for a while on my back deck to watch snow falling. At first the flakes were not very numerous and, because no breeze was blowing, they tumbled slowly, almost straight down. Before long I noticed that all the flakes were more or less equidistant from one another. It seemed as if each one needed its own private space in which to fall, an orb of air that enclosed and protected it throughout its descent. Gradually, the number of snowflakes increased until tens of thousands were falling all around me, yet each flake still had a "falling space" that was equal in size to that of every other flake, even though all the spaces were smaller now. Then a wind began to gust and drove the flakes past me at such a speed that I couldn't tell what was happening.

I've been wondering ever since about what I observed. Undoubtedly there's a definite, physical cause for the spacing of the flakes and one day I may learn what it is, but if I never find out, it doesn't really matter. What remains with me is the idea that whether it's a snowflake or a person, every natural creation and creature needs its own space. And that space helps to make and maintain its uniqueness.

I've also been wondering about how to photograph the spaces-between-flakes. Given similar conditions, it shouldn't be very difficult. However, because snowflakes and their spaces have become for me personal metaphors for people and their spaces, perhaps I should expand the project to include people. But what about the private spaces of ferns, trees, spiders, foxes, elephants, and waves? And how do all these spaces overlap – in time as well as in area? Because I spent a few moments on my deck

observing a natural phenomenon, I began to reflect on some important connections between natural things.

Connections! Everything in nature is connected to everything else. Whether you're photographing the rippled reflections of trees in the surface of a lake, documenting the feeding patterns of a giraffe, or showing the destruction caused by a tornado, you can sense the interactions between all natural things. By learning to focus not only on individual organisms, but also on niches, habitats, whole communities and how they are linked together in ecological systems, you will gain greater insight into the natural world, which in turn will help you to photograph it more intelligently. Many contemporary nature photographers clearly understand that the arrangements of lines, shapes, and textures occurring within a given area are visual documents of the ways that living and non-living things are interacting. The most observant develop a capacity for recognizing and showing the patterns that are intrinsic to even the most random natural design. By studying their pictures, you will obtain useful guidance for making your own.

Because the photography of natural things includes all forms of plants and animals, and the air, water, and soil habitats where they live and interact, the opportunities for making nature pictures are almost endless. You can begin with the geranium growing on a windowsill, a spider dangling from the ceiling of your garage, patterns of sunlight in a basin of water, or frost crystals on a tray of ice cubes; you can toss a hula hoop from your front door or deck (as I did, see pages 137 and 138) and photograph what's inside the circle where it comes to rest. By photographing what's near at hand, especially by choosing some nearby places and objects for careful pursuit as assignments, you will prepare yourself to take better advantage of opportunities that arise in more distant locations.

Broadly speaking, photographers tend to approach their subject matter in one of two ways – either with the intention of making realistic, documentary images or with a view to creating impressions. Many nature photographers make use of both approaches, sometimes simultaneously. When your main objective is to record a natural object, situation, or relationship as accurately as you possibly can, you'll want to observe both the overall subject matter and its detail very carefully. Only then will you be in a position to ask relevant questions and make sound decisions about composition, depth of field, and exposure. For instance, does a red granite boulder illuminated by late afternoon sunlight seem to glow more intensely when viewed somewhat from one side rather than from the front? If so, how do black shadows appearing in the rock surface from this angle affect exposure? If you want to show the pink lines in the otherwise white petals of a painted trillium – guidelines that lure a hungry insect to

the flower's centre where it pollinates the blossom as it obtains food – should you fill the frame with only the three petals and parts of the three surrounding sepals? From which camera angle are all the lines clearly visible? Do you need to show them all in order to provide the intended information clearly?

Perhaps creating visual impressions that evoke the power or beauty of the natural system is your personal challenge, and providing hard information only an incidental concern. Claude Monet did it with paints and brushes, but your tools and many of your techniques will be very different from his. Although you may be able to create impressions similar to Monet's, your main opportunity is to create imagery that is uniquely your own. What you share with Monet is the need to be so familiar with your tools and techniques that you can proceed confidently towards a visual goal. Because an intimate knowledge of design and craft is a necessary precondition for creating art, you may find it useful to set yourself repetitive technical assignments that produce consistent but nevertheless variable designs.

Take "zooming," for example. There are moments when atmospheric conditions create an impression of a special radiance, of light and creative power streaming from a central source, but more often than not a photographer is caught off guard, without a camera at hand, and misses the opportunity. If you want to recreate the effect and the feeling, try this exercise. First, using a zoom lens, make a simple composition of, let's say dark branches etched against a pale grey sky. Then, manually extend the focal length of your lens while exposing at slow shutter speeds or making time exposures of varying lengths. Zoom in on the branches and sky, let's say 20 times. Then make another composition, this one featuring strong colour contrast, and make 20 more "zoomed" compositions. Vary either or both original compositions; try overexposing for brighter tones, and repeat the exercise. Compare the images within each group and also compare the groups. Although no two pictures will be identical, observe how lines (the "streaming effect") are created and rendered by the differing zoom speeds combined with the differing shutter speeds. Which effects do you like most – those created by zooming slowly through the duration of an exposure, or those that result from zooming rapidly and then leaving the lens in a stationary position for the remainder of the exposure time? Only repeated trials and evaluation of the resulting images will enable you to predict future designs and your probable response to them.

Another very useful technique for creating impressions is selective or differential focus. The concept is simple. Using a telephoto lens or macro lens set at or near its widest aperture to produce shallow depth of field, poke the lens into some leaves or grasses. As you observe your subject matter through the viewfinder, rotate and extend the lens very slowly through its full focusing range, beginning at its minimum focusing distance and ending at infinity. You can stop at any point to study the effect, often a

small in-focus area surrounded by or combined with larger out-of-focus areas. If you like the effect at a particular point, but not the composition, alter the camera position slightly as you keep your eye to the viewfinder. Even a small shift in position can produce a major change in the picture design. Provided you aren't using a short focal-length lens (under 50mm especially) and are willing to place the front of your lens closer to the nearest grasses, leaves, or other subject matter than the minimum focusing distance of the lens, you can have a wonderful experience learning selective focus. This is not a difficult assignment, but one that may cause you moments of frustration as you proceed towards mastery of the technique. (For clear examples of selective focus, see pages 83 and 137.) This assignment and others that are tool-oriented or technique-oriented will help you to develop important skills that you can use to photograph a range of subject matter, both natural and manufactured. However, while your tools and your technical skills, used well, will enable you to communicate facts and evoke feelings about your chosen subject matter, they are not a substitute for exploring it. Pictures that really work, especially impressionistic images of nature, usually result from recognizing the particular physical properties and intrinsic designs of the subject matter, and then using those tools and techniques that enhance these designs or make them clear.

The three life habitats – air, water, and soil – and the sunlight that energizes them are the basics of nature photography. They are your creative environment. By choosing, first of all, assignments that encourage you to observe, though not necessarily to photograph, connections and interactions between light and air, water, and soil, you will strengthen your appreciation of nature as a creative process, and both your documentary and impressionistic images will show it.

A rhododendron bush and palm fronds

One March morning some friends and I spent several hours photographing in an abandoned Florida garden. After we'd been there for a while, I realized that I was falling into the bad habit of wandering around "looking for pictures," almost as if somebody had pinned photographs on trees, or laid them on the ground for me to "take." So, in order to stop looking and start seeing, I gave myself an assignment – two hours exploring a rhododendron bush and the palm fronds behind it. The smaller photograph shows the situation.

It took me half an hour to stop just looking at the subject matter and to start really exploring it. At first I kept some distance between the fronds, flowers, and the camera, and used a 100-300mm zoom lens to make compositions of sections of the plants. Eventually the lack of visual excitement led me to question why I was keeping my distance, so I moved up to the rhododendron and poked my lens in among the flowers. At the same time, using a wide lens opening for shallow depth of field, I began to focus along the entire range of the lens from one-and-one-half metres to infinity, varying the focal length from 100mm to 300mm as well. This helped me to let go of visual and technical preconceptions. After several more minutes exploring, it occurred to me that the bright, rich pink flowers did not have to be in the foreground and the dark palm fronds in the background, so I changed camera position to reverse the visual relationship between the two and kept on exploring.

There's no way of predicting when visual exploration ceases to be work and becomes a creative adventure instead, but certain conditions have to be met. The most important is becoming involved in a caring way with the subject matter – whether a person, a sand dune, or reflections in a piece of chrome. You can only care about somebody or something you know, so the process of getting acquainted that precedes real involvement is time well spent.

In the end the rhododendron blossoms and palm leaves became my friends and guides. It was the fronds that, in effect, said to me, "If you want to show our rhythmic nature, observe us with your 100mm macro lens," and the blossoms that expressed their willingness to play a supporting role.

In the larger image, the somewhat interpretive approach to the subject matter is based on nature itself. Balancing the three leaf stalks and the spaces between them represents natural and visual order. Orienting them obliquely helps to convey the natural dynamic of life and growth. The out-of-focus pink rhododendron blossoms are background music, expressing my feelings about the subject matter and the beautiful morning.

Timber wolves

As a boy growing up on my parents' farm, I discovered that cows, pigs, and chickens had minds of their own. In order to make sure that they co-operated with me in their care and feeding, I started observing their behaviour. I soon learned that many animals are innately curious and that by arousing or dampening their curiosity, I often could get them to respond in ways that I wanted.

For instance, if the cows showed no interest in coming to the barn for milking, I might start crawling around the pasture on my hands and knees. Spotting this apparently strange creature in their familiar surroundings, first one cow and then another would come running towards me – ears up – to find out what was going on. Before long I had a line of cows following me home, and I was able gradually to resume my normal walking position. Years later when I began photographing wild animals, I applied the lessons in animal psychology I'd learned back on the farm – and they worked!

The timber wolves I photographed for this assignment were semi-wild, living in a pack in a forested enclosure of several hectares. I felt certain they would check me out as soon as they spotted me, which they did by running towards me and even sniffing me. However, I wanted photographs of them interacting with one another, not with me, so I refused to respond to their interest by standing still and then by raising and lowering my camera until they became accustomed to the movement. It wasn't long before they were sufficiently bored with me to resume their normal activities, and I was able to photograph them in the way I wanted. Whenever they started to move too far away I'd make an unusual sound or do something uncharacteristic – a swift, sudden movement, perhaps – to lure them back within easy range of my lens.

Both wild and domesticated animals (including photographers) may suddenly behave in unexpected, though not necessarily uncharacteristic ways. These brief moments may be expressive and well worth capturing on film. If you have preselected a shutter speed and lens opening, as I did here, you can often respond quickly enough to press the shutter release a split second before the peak action. Or, if you have a good supply of film, you may want to pre-set the shutter for rapid exposures (two to four frames per second) and select the best picture afterward.

In this image the invisible oblique line or movement created by the placement of the wolves' heads visually reinforces the dynamic interaction, as does the oblique orientation of their jaws. Using black-and-white film also helped, because the emphasis on these lines is not diminished by colours present in their fur.

Looking into and out from a specific site (minimum requirement: 40 carefully considered images per location)

This is a slight variation of an assignment I've given many workshop participants. Usually I ask them to pick a number between 50 and 100, let's say 83, then to walk 83 steps from a door, mark off a square metre, and make photographs while looking into and out from the little plot. It's an assignment that most photographers can easily do at home, and one you can continue indefinitely.

To illustrate clearly what's possible, I chose late November – a supposedly uninteresting time of year where I live – to toss a hula hoop off my rear deck. You can see from the small photograph that the spot where the hoop landed seemed to hold little promise at first glance. However, subsequent glances at the time and during the next 24 hours proved what I already knew – wherever you are is as good a place to observe and to make pictures as any other place. The two larger pictures I've chosen are somewhat impressionistic, a contrast from the documentary images of textural patterns in the same field (see following assignment).

If I could recommend only one assignment to every photographer, it would be this one. Because you have no control over the precise location and subject matter, you will have to abandon at least some preconceptions about what is worth photographing. You will become less oriented to labels and more observant of intrinsic designs. If you start encountering mental blocks, keep on shooting. It's when the project starts to become difficult that you know you are entering new visual territory. Everything that follows is progress.

To challenge yourself more make 20 compositions looking into the hula hoop or square metre, and 20 more standing inside it looking out.

As soon as I'd tossed the hula hoop, I used my 100mm macro lens to explore the place where it had landed (see larger image). There was some water on the leaves and grasses that, in the sun, formed striking highlights. I carefully arranged some of these in the picture space by carefully adjusting camera position, opened the lens to its widest aperture for minimum depth of field, and focused manually examining points nearer and farther away than the one I eventually settled on. Auto focus was of no help, as the lens and I disagreed seriously on the best point.

From the centre of the hula hoop I could easily aim my cameras at nearby trees silhouetted against the evening sky. Because the wind was tossing the branches, I decided to capture this impression by making a multiple-exposure image, and moving the camera a little between each of the nine exposures. I also experimented with blurring – exposing at $^1/_4$ second as I moved my camera up and down or on the oblique.

A natural tapestry in four seasons

In the four images on the next two pages, you will see part of the field behind my house, but not always the same part. As grasses and other plants begin to grow in the spring, I mow first in one area and later in another, depending on what the plants are doing. The result is an ever-changing mix of tones and colours that, viewed overall on any day between April and December, has the rich textural appearance of a fine tapestry. Even when the field is buried in snow, the moving direction of light defines patterns of undulations and protruding grasses, all frequently dotted with points of sparkling brilliance. This is my very own magic carpet.

Over the years I'd made thousands of photographs in the field – dew on grasses, spiders' webs, close-ups of flowers, field mice, a garter snake. But I'd made very few images of the field, especially as a tapestry. My assignment was to remedy this situation, to photograph the changing textural patterns of the meadow-carpet in all seasons and at all times of day.

I began to observe whole sections of the field more carefully. An assignment does that; it forces you to concentrate visually. On several occasions I climbed onto the roof of my house and studied the field from that elevation and perspective, but more often I walked across the field, pretending that I was in an airplane and staring down at a landscape thousands of metres below. This helped me to remove the labels from "grasses," "flowers," "frost," and thus to see them as lines and shapes woven together into a vast textural pattern.

As you can tell from the four photographs on the following pages, my approach to this assignment has been entirely documentary. To me the appearance of the subject matter is always so interesting that my main task is simply to present it clearly in every image. No special tools or techniques, just careful observation of every part of the composition, with particular attention to corners and edges, to make sure that no shape is large enough or line definite enough to detract from the overall textural pattern.

A sheet of tiny bluets in the noonday sun, mid-May

Yellow hawkweed plants and blossoms in soft morning light, early July

The rhythmic pattern of dead grasses in slanting sunlight, late October

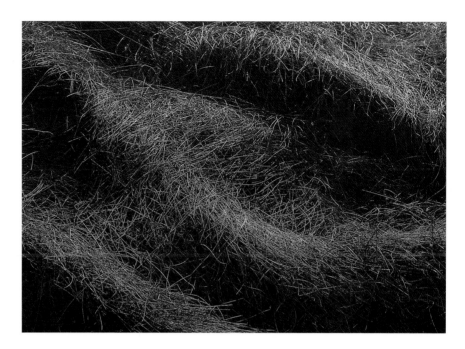

After the first snow in December

Human constructions and manufactured things

Several years ago I attended a conference in Ottawa. Arriving in the evening, I checked into my hotel and went to bed immediately. Early next morning before dawn, well rested and eager to start the day I jumped out of bed and opened the curtains on a wintry scene. Below me and into the distance, thousands of street lights cast golden circles on the deep snow. Above them all, suspended in the rich blue twilight of dawn, the silver orb of the full moon shone down on the Peace Tower of the Parliament Buildings. The magnificent scene is recorded forever in my memory – but only in my memory. Expecting to spend all my time at the conference, I had not bothered to pack a camera.

More recently I attended another conference, this one in Calgary. Returning to my room during a coffee break, I glanced out the window to see strong, warm light illuminating tall downtown buildings. Having learned a lesson in Ottawa, I grabbed a camera from my suitcase – and ran! Half an hour later I was back at the conference table, this time with my memories and several photographs. (See page 145.)

The pictures I made during those 30 minutes didn't constitute an "assignment" in the usual sense of the word. I simply took advantage of an opportunity. If you're a working person who enjoys the challenges of seeing and making pictures, but who has little time for photography, you can create your own opportunities for keeping in shape visually and technically by regularly carrying a camera with you to work and by setting yourself short-timed assignments. You can accomplish a lot in 15 minutes – at a freeway exit, along a side street, from an office window, or in a repair shop.

You will be amazed at the number and variety of pictures you have at the end of a month, provided you do an assignment every day – perhaps designs in equipment

stacked against a wall, shadow patterns on a factory or office floor, water drops streaming down a window pane, children in a school playground, rows of computer screens, reflections of buildings in the glass façades of other buildings, aerial views of traffic flowing, zoomed shots and panned shots, images that you have overexposed or under-exposed to create a certain effect, compositions that depend on using selective focus and a very shallow depth of field and, because your camera was handy, photographs of unexpected events or scenes.

Regardless of their size, many manufactured objects have a strong design component that is related to their use or function. Other human designs or aspects of designs are largely decorative, appealing to some people's sense of beauty. In both cases, the designs tend to be more obviously ordered than natural designs. Photographers who want to produce good visual documents of human constructions and manufactured objects should respect and make use of this created order. However, if accurate documentation is not your goal, you can use existing lines, shapes, textures, and perspectives as visual springboards or jumping-off points, much as I did for the paperweight assignment (see pages 147, 148, and 149).

You'll receive a second benefit from regularly scheduled or short daily assignments. When you go on a weekend or vacation trip, you'll find yourself seeing and photo-graphing more easily and more creatively than you ever did before you embarked on a program of regular exercise.

Exterior of a building (time available: 30 minutes)

Because I used a tripod for this assignment in downtown Calgary, I was able to make more and better pictures in the brief time I had available. The weather was sunny but cold and windy, and despite my winter clothes I felt the chill. The tripod held my camera steadier than I could and freed me to do some running on the spot when I needed to warm up. It also enabled me to adjust the focal length of my zoom lenses for precise arrangement of lines and shapes.

I found my 28-85mm lens more useful than I had expected. It caused vertical lines and edges in the building to converge, producing an accurate sense of the perspective I had from my position at street level. When I wanted less perspective or undistorted lines and shapes on a flat plane, I switched to a zoom lens of longer focal lengths.

Deciding on exposures was not difficult, but I had to adjust the lens openings or shutter speeds up or down depending on the proportions of light, middle, and dark tones in my compositions. Because I had the camera on a tripod, I usually varied the shutter speed, having already focused and selected the lens opening (depth of field) I wanted.

The tone and colour contrasts of dark blue glass and bright warm reflections triggered the initial emotional response that galvanized me into action and provided continuing motivation. My use of these tones and colours in the compositions – my aesthetic response – not only expressed my emotional reaction to the tones and colours per se, but also had symbolic intent. The dark tones and cool blue colour, temporary though they were, seemed relatively permanent when compared to the fleeting gold reflections. As I photographed, I became increasingly conscious of how highlights in our lives continue to illuminate our existence long after they have disappeared.

Many city dwellers can make photographs like these every day the sun is shining, and muted variations when it isn't. Exteriors of modern buildings provide excellent opportunities to peel away familiar labels and work with the visual building blocks of line, shape, and perspective. In fact, with only a little persistence you can soon assemble a stunning collection of abstract and semi-abstract images.

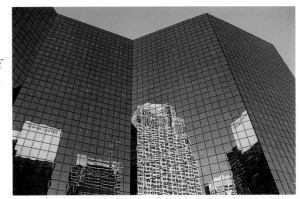

A clear glass paperweight

One year for Christmas a friend presented me with a clear glass paperweight. It became a travelling household fixture, moving mainly between my desk and kitchen table, but also turning up in the most unexpected places. One day I found it sunning itself on the railing of my deck and, noting its prismatic qualities, I decided to photograph it. Two weeks later, I realized that this was becoming one of my more ambitious projects, despite the fact that the paperweight was still sitting in the same spot on the deck.

From the first moment I observed it carefully the paperweight became something else. I didn't try to give it a new label, but viewing it from certain positions and directions of light, I found myself photographing a rising planet. As my lens-spaceship drew closer, the appearance of an orb dissolved into a thousand points of light or became a spectacular aurora sweeping across a midnight sky. At other times I passed beneath a succession of crystal arches along avenues of silver-blue ice. The longer I looked and the more I photographed, the greater was my sense of having travelled to a planet dramatically different from Earth.

I used my 100mm macro lens for this assignment, shooting in sunlight at all times of day but especially around noon. No filters, flash, or reflectors were required. My camera was always on a tripod, which I shifted much less often than the paperweight itself. The merest change in the proximity of the paperweight to the lens, or a slight rotation of the paperweight, or a minor adjustment in focusing distance would frequently cause a dramatic change in visual effect.

Although I have over 1,000 images of the paperweight and have assembled some of them into an 11-minute audio-visual sequence, I have a strong sense that my work on this project has barely begun.

I cannot think of this orb as a glass paperweight. The moment I begin to observe it, I am travelling in interplanetary space and experiencing all the awe and wonder that I feel about the cosmos. My notion of time is similarly affected. If, as astrophysicists claim, the universe is about 15 billion years of age, I want another billion or so myself to go exploring.

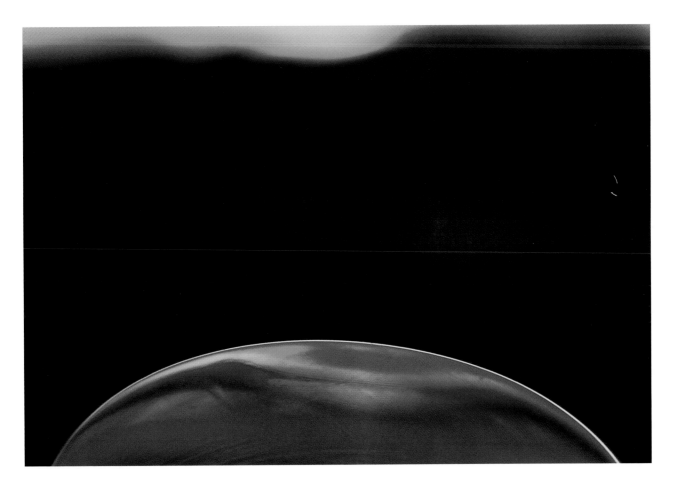

After travelling for an hour – or perhaps a million light-years – I began to zoom in on the inner space of the paperweight, which contained whole galaxies of auroral light. As waves of colour curved and billowed across the blackness, I listened to arias, fugues, and symphonies. And then I rocketed on to somewhere else.

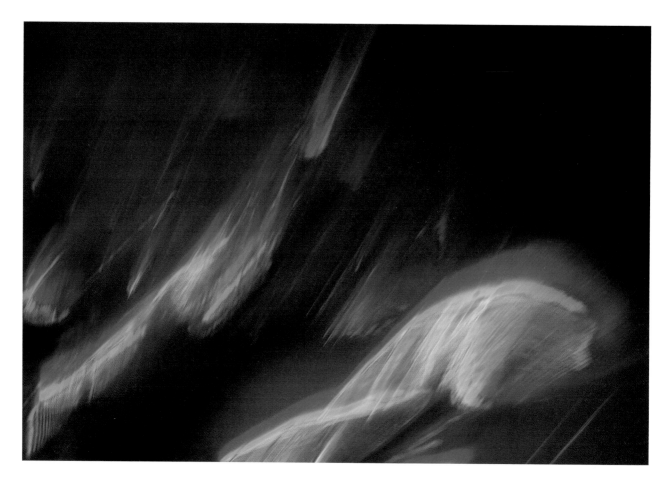

Home at last, I picked up the little paperweight – holding the cosmos in the palm of my hand – then placed it on the railing of my deck, set up my tripod, camera, and 100mm macro lens and began a new voyage.

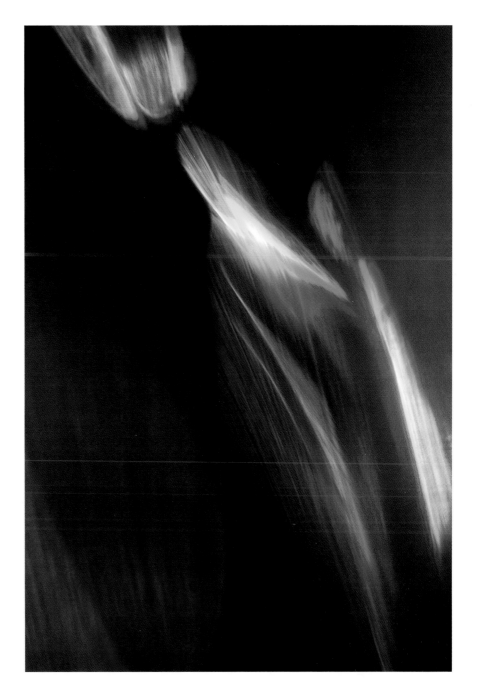

Laundry on a clothesline (minimum requirement: 100 images)

If you or a neighbour has a clothesline, hang up several sheets or other laundry one windy day and prepare to be challenged. This is a very demanding assignment, one that requires swift decision-making, excellent eye-and-hand co-ordination, and split-second timing. Even if you possess all these skills, you'll still end up discarding a lot of photographs. Don't let that bother you. Be proud of your successes and grateful for having survived photographic "boot camp."

The main visual challenge will be assessing the overall arrangement of lines, shapes, and textures in the viewfinder instantly and repeatedly. The main technical challenges will be focusing and exposing accurately. Continual, rapid design changes in the sheets, caused by the wind, will mean that the best point of focus is constantly shifting. Since the camera can't assess the composition you want, relying on automatic focus will be a very frustrating experience, except when all parts of all the sheets are more or less on the same plane and sidelighting produces textures the lens can "grab onto." On balance, I prefer to do my own focusing rather than having auto focus shift crazily at the precise moment I'm pressing the shutter release.

Definitely experiment with various shutter speeds. Slow speeds, such as $^1/_2$ to $^1/_{15}$ second will produce blur, softness, and a sense of movement. Fast speeds yield sharp detail and clean edges.

Some photographers may feel that, regardless of shutter speed, rapid-fire exposures will overcome most of their difficulties. Not so! Although it's possible that you'll get an occasional good composition you'd otherwise miss, you'll end up with a much higher ratio of discards and you won't have pushed yourself. If you really work at this assignment, you'll develop visual reflexes that will also be useful in many other dynamic situations.

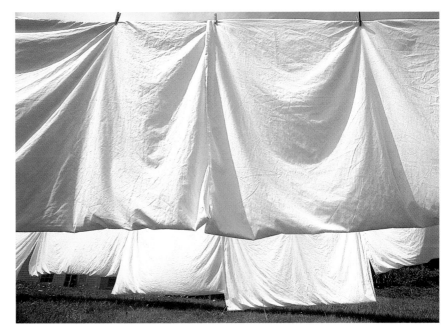

This was a challenging assignment – technically and visually – but ultimately a very satisfying one. My photographs ranged from literal documents to non-representational designs. Because the sheets were blowing constantly and because I was experimenting with several different approaches to photographing them, my failure rate was high. However, even the least successful attempts were instructive, often providing me with ideas for future pictures that I would never have considered otherwise.

Interior of deserted houses

The desert ghost town of Kolmanskop is a long day's drive from Kamieskroon, the Namaqualand village where Colla Swart and I have conducted workshops for many years. In one sense Kolmanskop is an easy assignment. The deserted buildings and constantly shifting sand are so visually arresting that nearly anybody can make some reasonably good compositions easily and quickly. But this extraordinary place deserves to be experienced slowly, deeply – with both mind and heart – and photographed with all the skill and care you can muster.

The symbols and the conditions that make Kolmanskop a significant emotional experience are necessary for making it a good photographic one. The noisy chatter and careless footprints of a large group of visitors inhibit thoughtful observation of the natural and the human designs and detract from careful image-making. At Kolmanskop, Colla and I went our separate ways, yet both of us made certain to leave no tracks that we would regret later. We even avoided walking on banks and stretches of sand whose austere and pristine beauty we wanted simply to observe.

I used a tripod for every picture, not just to prevent camera movement at slow shutter speeds, but also to study my compositions carefully and to make minor adjustments with precision. Both my 28-85mm and my 80-210mm zoom lenses proved especially useful throughout their entire range of focal lengths for composing pictures and avoiding disturbance of sandy areas.

Instead of carrying a camera bag that I'd have to be constantly putting down and picking up, I wore my photographer's vest, so a new roll of film, a fresh battery, a different lens, or a snack was instantly available and anything I no longer needed could be stored immediately.

Because I kept equipment to a minimum and used my vest for quick, convenient storage, worked by myself, and took the time to compose and expose each image carefully, I felt a sense of completeness when the sun set on the second day. That evening Colla and I celebrated with a bottle of fine Cabernet Sauvignon, and next morning headed north towards the enormous dunes of Namibia's Great Sand Sea – our next assignment.

Sometimes a scene is potentially so symbolic that the wisest approach is to present it in a realistic, documentary way – to let it speak for itself, as it were. The photographer's challenge – an enormous one in such cases – is to decide precisely what to include in the picture and to arrange the visual building blocks in a manner that enables the symbolism to communicate itself effectively.

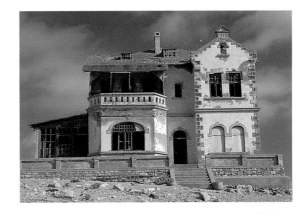

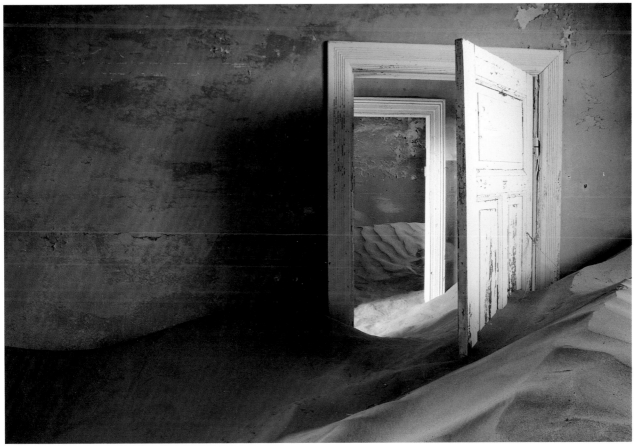

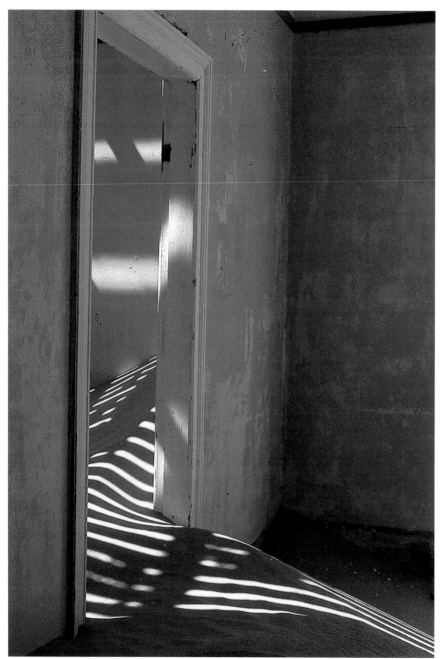

The continuous change in the direction of light meant that I could return repeatedly to a spot and find something new and interesting to photograph each time. The problem in these ghost houses was that there were too many compelling spots. Because I wanted to experience the feeling of the place, I chose not to rush, but to select certain sites for repeated visits and others for a single visit when the light would be creating a particular effect.

This was one location I visited several times during the middle hours of the day. As the sun's rays slanted first one way, then another, I adjusted my basic composition of the overall scene to take advantage of the particular orientation of the lines. At first I had some difficulty determining the best exposure. Although the light and dark lines were equal in number and visual importance, I settled on slight underexposure (0.5 increase in shutter speed) to retain both the darks and the highlight details.

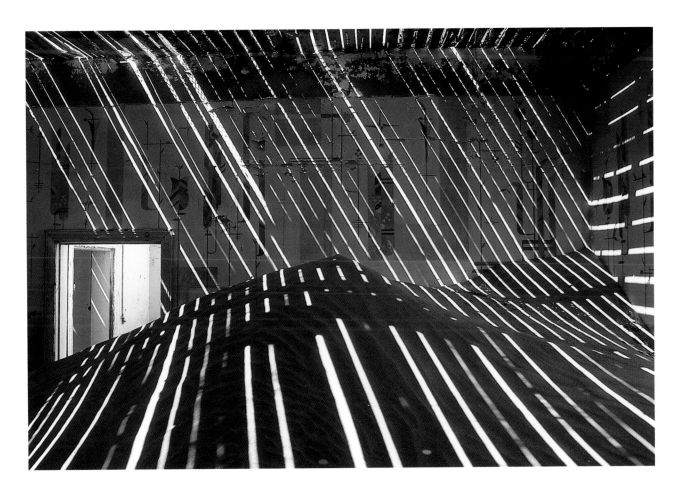

Using the in-camera meter to determine brightness, I often increased the recommended exposure by decreasing the shutter speed in rooms where the light was dim and diffused in order to retain delicate tones and desaturated hues. Usually a decrease of one-half or one shutter speed was sufficient to compensate for a film's tendency to underexpose slightly at speeds of less than one-quarter second. Because having maximum depth of field was more important than might appear, I did not want to increase exposure by using a wider lens opening.

With this and many other interior situations I had to be extremely careful about where I positioned the lens. Aiming at a slight angle to the subject matter – either up or down, or to one side – often converted vertical and horizontal lines to annoying obliques. Here, I kept the sofa horizontal to retain the sense of rest.

Making an album

The final afternoon of every workshop is a special time. First we have an exhibition of photographs accompanied by music – each participant's "Ten Favourite Photographs" made during the workshop. These may include images that are not necessarily the best designs, but have a strong emotional appeal or effective symbolic content. Each short presentation is invariably followed by an enthusiastic burst of well-deserved applause. Then sometimes after a short break to savour the sense of excitement and satisfaction, somebody (usually one of the workshop participants) presents "The People Show." This is an organized collection of the funniest and generally most awful pictures we made of each other during the week, with a running commentary provided by the person who assembled the show and anybody else who wants to add two cents' worth of nonsense.

I'd like to adapt and combine these two sorts of presentations for the final chapter of this workshop book by showing you a few of my favourite pictures of the people I've met and photographed over the years – in Africa, North America, and elsewhere. On the whole I feel that the designs support and, in some cases, provide the expressive content, but like the pictures in any personal photo album several of these could have been improved in one way or another.

Like most people, I'm much more likely to keep not-so-great pictures of close friends and relatives – provided I've captured something I like about them – than similar pictures of acquaintances or strangers. The less well I know a person the more I look for a universal quality, and the more I consciously strive to support it with good design. In other words, our personal relationship with the people we photograph can have a huge influence on the quality of imagery we are prepared to accept.

That's probably as it should be. It's better to have a less-than-wonderful photograph of your late grandfather than none at all or to have those snapshots of your best friend covered in lemon meringue pie and whipped cream, even if they are all somewhat underexposed. Photographs like these usually arouse our emotions because of their content (the person or persons pictured), not because of their design.

To a large degree our interest in something – anything – determines whether or not we photograph it. People who like flowers photograph flowers; people who enjoy watching military parades photograph military parades. People who are keen on both photograph both, but rarely photograph hockey games, antique cars, or blue jeans – in which they have little interest. The old adage that we see what we want to see is as apt for the pictures we make as it is for our lives generally. Unfortunately, the result is that we miss out on many things we might like a great deal if only we allowed ourselves to look at them carefully, which is partly why photographing something that doesn't appeal to us can be an important project. Everything we do to expand our creative environment feeds our imagination, which in turn helps to expand our creative environment still more – in a wonderful cycle of personal growth.

Nobody knows more about all of this than children. They are naturally creative. By example they can teach adults who are willing to learn how to loosen up, to be spontaneous, to imagine, to fantasize, to dream, and to hope! In fact, children are among the most exciting and challenging people I've ever met, which is why I have so many pictures of them, and why I've included a few of my favourite ones in this photo album. In sorting through my images I discovered that although I have numerous pictures of children only, I have as many or more of children and adults relating in some way. Unconsciously I've been documenting my feeling that in child-adult relationships, the adults have as much to learn as the kids. When we freely spend time with children, we are revisiting a spontaneously creative period in our own lives, a time that need not have ended. By letting children lead us back to meet the child we once were – and, deep down, still are – we can revitalize our adult inner selves.

After the workshop is over or you've finished reading this book, why not consider undertaking the ultimate assignment – photographing children? It will be a lot of fun, provided you enter into their activities. That means spending quite a bit of time with them. If you've just met, there's likely to be an initial period of shyness, or the children may adopt formal poses that adults often expect of them. In both cases, it's often useful to start shooting as soon as possible, but to offer no guidance or direction of any kind. As children hear the camera clicking again and again (you may want to shoot without film at first), they invariably begin to relax, steal glances at each other, giggle, or "ham it up." Before long they are guiding and directing you, and you'll have endless opportunities to make good pictures.

Next, have the children photograph you. A simple digital camera that provides instant results is a good choice. If there's more than one child, let them take turns with the camera and encourage each of them to make several pictures of you. Look carefully at the photographs they made of you – not at the picture designs, but at you. What were you doing? Sitting on a rock, leaning against a car, or posing on a park bench? Are there any pictures of you "making faces"? Licking an ice-cream cone? Jumping in the air? Or curled up, pretending to be asleep? Did you even think of doing any of these things?

Make sure the children get to see the photographs they made of you. Their exclamations, comments, and body language will be revealing. Then, show them the pictures you made of them, perhaps a short slide show that includes the funniest and some of the best by your standards. Again, listen to and watch their reactions. After the show, ask them if they'd like to go to a new place and make some more pictures. Chances are good that the second time you won't act or look so much like a bump on a log.

Most of us realize that we didn't have to forfeit the spontaneity and willingness to experiment we had as children in order to become healthy, responsible adults. In fact, we know that giving up these qualities or burying them deep inside, instead of building on them, makes us less healthy and less functional. This assignment – photographing kids and having them photograph you – is a super way to take constructive action without having to engage in unnecessary personal analysis.

The response of children to their pictures of you and yours of them may surprise you. You may not understand some of their reactions. But this can happen with any viewer or group of viewers. Each one of us possesses a unique combination of life experiences that influences our responses to other people, events, and objects, and therefore to images of them. No matter how effective the picture design may be, your favourite photograph of your daughter or of the Grand Canyon may not be mine. Or, perhaps like the occasional urban visitor to my country home, some viewers won't be able to relate to "all that open space" in your pictures, or they'll experience a sense of fear when they see images of grasshoppers, deep woods, or children swimming in a river instead of a pool. Don't allow these normal differences in taste, feeling, and judgement to sap your confidence in your picture-making, but regard them as opportunities to learn about others and why they respond to your images in certain ways.

Differences are the stuff of creativity. They make change, growth, and dynamic relationships possible. Managing differences positively means recognizing – in photography as in life generally – that your individual uniqueness enriches the lives of everybody else. I've said it before, but it's worth saying again: photographers who are open to the world around them, who are willing to give up personal preconceptions about how things "should" look, and who have wedded this openness to a good working

knowledge of visual design, can make extraordinary breakthroughs.

On the one hand, making fine photographs is a very personal way to be with your own thoughts and feelings in a creative milieu. On the other hand, it is always a shared experience – first, with whatever subject matter is your partner in the creative act, and second, with your friends, family fellow photographers, and whoever else sees your images and responds in his or her own uniquely personal way. By reaching into yourself and reaching out to others through photography, you will ultimately make discoveries both about yourself and about the world around you.

Mother and daughter, Canada

Father and son at motorcycle rally, Australia

My parents with their grandson,
Canada

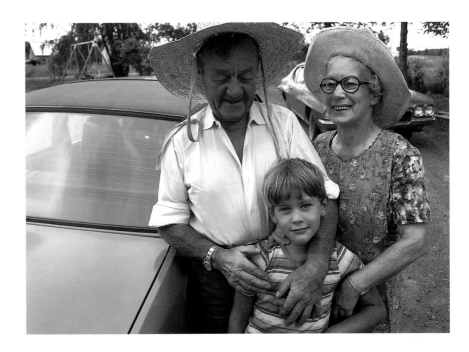

Family after breakfast in their
kraal, Botswana

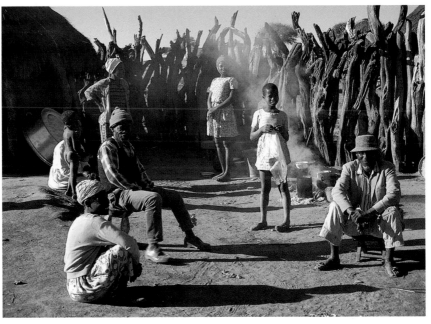

Jesse playing hide-and-seek, Canada

Brothers, Botswana

Nuns on a shopping spree, South
Africa

Photographer caught at work,
Canada

ABOUT THE AUTHOR

Freeman Patterson lives at Shampers Bluff, New Brunswick, near his childhood home. He has a bachelor's degree in philosophy from Acadia University and a master's degree in divinity from Union Seminary (Columbia University). He studied photography and visual design privately with Dr. Helen Manzer in New York. He began to work in photography in 1965, and numerous assignments for the Still Photography Division of the National Film Board of Canada followed.

In 1973 Freeman established a workshop of photography and visual design in New Brunswick, and in 1984 he co-founded the Namaqualand Photographic Workshops in southern Africa. He has given numerous workshops in the United States, Israel, England, New Zealand, and Australia. He has published eleven books and written for various magazines in Canada and the United States and for CBC radio. He has been featured on CBC television's *Man Alive, Sunday Arts and Entertainment*, and *Adrienne Clarkson Presents*. He was appointed to the Order of Canada in 1985.

Freeman was awarded the Gold Medal for Photographic Excellence from the National Film Board of Canada in 1967, the Hon EFIAP (the highest award) of the Fédération Internationale de l'Art Photographique (Berne, Switzerland) in 1975, honourary doctorates from the University of New Brunswick and Acadia University, the gold medal for distinguished contribution to photography from Canada's National Association for Photographic Art in 1984, and the Photographic Society of America's Progress Medal (the society's highest award; previous recipients include Ansel Adams, Eliot Porter, Jacques Cousteau, and the Eastman Kodak Company) in 1990.

In 2001 he received the Lifetime Achievement Award from the North American Nature Photography Association, and in 2003 he was awarded the Miller Brittain Award for Excellence in the Visual Arts.